KU-480-778

Degas

Keith Roberts

with notes by Helen Langdon

Phaidon · Oxford

Phaidon Press Limited, Littlegate House, St Ebbe's Street,
Oxford, OX1 1SQ

First published 1976
This edition, revised and enlarged, first published 1982
Second impression (with corrections) 1987
© Phaidon Press 1982
Introductory essay © Keith Roberts 1976, the estate of Keith Roberts
1979

British Library Cataloguing in Publication Data

Roberts, Keith
 Degas. – Rev and enl. ed – (Phaidon colour library)
 1. Degas, Edgar
 I. Title II. Langdon, Helen III. Degas, Edgar
 759.4 ND553.D3

 ISBN 0–7148–2226–4
 ISBN 0–7148–2240–X Pbk

All rights reserved. No part of this publication may be reproduced, stored
in a retrieval system or transmitted, in any form or by any means,
electronic, photocopying, recording or otherwise, without the prior per-
mission of Phaidon Press.

Printed in Portugal by Printer Portuguesa, Lisbon

The publishers wish to thank all private owners, museums, galleries and
other institutions for permission to reproduce works in their collections.
Particular acknowledgement is made for the following: Plate 2 — repro-
duced by courtesy of Birmingham Museums and Art Gallery; Plate 15
and Figs. 15, 27 — reproduced by courtesy of the Museum of Fine Arts,
Boston; Plate 29 — reproduced by courtesy of the Fogg Art Museum,
Harvard University, Cambridge, Mass.; Plates 39, 43 — Collection of the
Art Institute of Chicago; Fig. 37 — The Cleveland Museum of Art;
Plates 34, 47 — The National Gallery of Scotland, Edinburgh; Plate 18 —
Courtauld Institute Galleries, London; Plates 3, 23, 31, 41, 45 — repro-
duced by courtesy of the Trustees, The National Gallery, London; Plate
24 — reproduced by courtesy of the Trustees, The Tate Gallery, Lon-
don; Plates 4, 9, 11, 13, 17, 19, 22, 26, 27, 30, 38, 42, 46 and Figs. 3, 4, 6, 9,
11, 12, 13, 14, 16, 19, 23 — Musée National du Louvre, Paris; Plate 14 —
Musée des Beaux-Arts de Pau, France; Plates 1, 6, 10 and Figs. 20, 34 —
National Gallery of Art, Washington.

Degas

MERTHYR TYDFIL
TECHNICAL COLLEGE
LIBRARY

returne
mi

MERTHYR TYDFIL COLLEGE

5880

Acc 1621

759.4

Degas

If the Word Association Test were applied to Degas, what might be the results? For a great many people: images of the ballet, of race-horses and of women washing themselves. The more knowledgeable might add: an Impressionist, a wit, a man who went slowly blind. The expert could extend the list further: a superb copyist of the Old Masters, an exquisite draughtsman, an exceptionally intelligent artist whose attitude towards Impressionism was equivocal.

Degas was, and has remained, a somewhat paradoxical figure. After Seurat he is the least well known individual personality among the major Impressionists and Post-Impressionists. Set beside the hedonistic, easy-going Renoir, the flamboyantly arrogant Gauguin or the self-destructively intense and pathetic Van Gogh, Degas seems an aloof and very private man, self-absorbed, inclined to cynicism, his feelings concealed behind a battery of often scornful wit, and with more than a hint of the prematurely aged response to life sometimes found in highly intelligent people who have few illusions and little faith in their fellow men. Like Flaubert, the creator of that pioneering masterpiece of Realism, *Madame Bovary*, and like Leonardo da Vinci, the Renaissance artist with whom he had most in common and whose works he copied, Degas was a pessimist. His art is without the simple joyous and affirmative qualities that one associates with the paintings of Renoir, Monet, Pissarro, Sisley, Gauguin and Van Gogh. Reticence, control and a highly calculated kind of objectivity lie at the heart of Degas's vision. He was not what is usually thought of as a lovable man; and his art has its distinctly chilly side. But the response to visual facts was so fastidious and so acute, the mastery of design so vigorous and so sure, and the feeling for art, for what a work of art is about, so intense that Degas's œuvre is among the most deeply satisfying artistic achievements of the nineteenth century, an age astonishingly rich in great painting.

He was born Edgar De Gas (later contracted to Degas) in Paris on 19 July 1834, the eldest of five children. Madame De Gas belonged to a French family that had settled in America. Degas worshipped his mother, and her death in 1847, when he was thirteen, was a tragedy he never forgot. His father was a banker of cultivated taste, devoted to music and the theatre, and he encouraged his son's artistic inclinations. From 1845 to 1852, Degas studied at the Lycée Louis-le-Grand, where he was given a good classical education; his best subjects were Latin, Greek, History

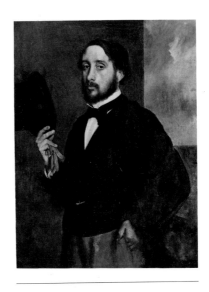

Fig. 1
Self-portrait

OIL ON CANVAS, 92.1 × 69 CM. C.1862. LISBON,
CALOUSTE GULBENKIAN MUSEUM

and Recitation — an early symptom of his life-long passion for the theatre and its calculated artifice.

Degas then enrolled in Law School, but he did not stay long. He was too anxious to be a painter. Already, in 1852, he had been allowed to transform a room in the family home in the Rue Mondivi into a studio; and in the following year he began to work under Félix Joseph Barrias. He spent a good deal of his time copying the Old Masters in the Louvre and studying the prints of Dürer, Mantegna, Goya and Rembrandt. In 1854, Degas went to study with Louis Lamothe, an ardent disciple of Ingres (1780–1867), the great upholder of the classical tradition of painting going back to the Italian High Renaissance, a tradition for which Degas, too, was always to retain the greatest respect.

In 1855, Degas began to study at the École des Beaux-Arts; but he found the course unprofitable and the régime too restricting. To study the classical tradition on home ground seemed more sensible. With hospitable relatives in Florence and Naples, he was able to make long and regular trips to Italy between 1854 and 1859. Degas studied hard, making copies of Italian pictures he admired and filling sketchbooks with studies, compositions and precepts. Of his Impressionist contemporaries, only Cézanne was to study and copy the Old Masters to anything like the same degree. When in Rome, Degas enjoyed the lively and stimulating company of friends and acquaintances living either in or near the French Academy.

A minor incident of the mid-1850s highlights the ambiguities of Degas's aesthetic position. Among the most admired features of the 1855 Paris World Fair was a gallery devoted to the work of Ingres, the most respected French painter of the age. At the planning stage, Ingres asked for an early *Bather* of 1808 to be included, but the owner, a friend of M. Degas senior named Edouard Valpinçon, refused to lend the picture. The young Degas was incensed that a mere owner should have rejected the plea of a great artist; and he was able to persuade M. Valpinçon to change his mind. Impressed by the student's ardour, Valpinçon took Degas to see Ingres, to whom he related the whole story. The painter, then in his mid-70s, was touched, and, when he learned that the boy wished to become a painter too, gave him a piece of advice: 'Draw lines, young man many lines, from memory or from nature; it is in this way that you will become a good artist.'

Like the advice often meted out by the old and famous to the young and unknown, Ingres's words were sympathetic, rather vague and a shade patronizing. But Degas was never to forget them; they formed the substance of his favourite anecdote. The meeting had been all too brief but it was to play a symbolic rôle in

Fig. 2
Portrait of a Woman (after Pontormo)

CANVAS, 65 × 45 CM. C.1857. OTTAWA, THE NATIONAL GALLERY OF CANADA

6

his life. The plain words of Ingres came to assume the character of magic cyphers implying, as far as Degas was concerned, a whole philosophy of art, exemplified in the thirty-seven drawings and twenty paintings by Ingres that he eventually owned.

It might at first seem strange that Degas — known to everyone who has ever been inside an art gallery as the painter, par excellence, of the ballet (e.g. Plates 11, 16, 19 and 46), the race-track (Plates 9, 15 and 27), the theatre (Plates 12 and 25) and the nude in domestic surroundings (Plates 36, 41 and 47) — should have revered the sayings and work of an artist apparently so very different. Ingres was an exceptionally conservative figure, who had set his face against nineteenth-century progress, worshipped at High Renaissance shrines and lovingly borrowed ideas from the work of Raphael. Classical myths and episodes from religious and secular history were his preferred subject-matter.

A little of the mystery evaporates, however, when we recall that Degas in his youth tried to paint in the Ingres tradition. Three of these early history pictures are reproduced here: *Semiramis building Babylon* (Plate 4), *The Young Spartans* (Plate 3) and *Scenes from War in the Middle Ages* (Fig. 3). The first two, in which the figures are spread out across the canvas in a shallow frieze, are even composed in the Ingres manner. And like Ingres, Degas made

Fig. 3
Scenes from War in the Middle Ages

PAPER PASTED ONTO CANVAS, 85 × 147 CM.
1865. PARIS, MUSÉE D'ORSAY

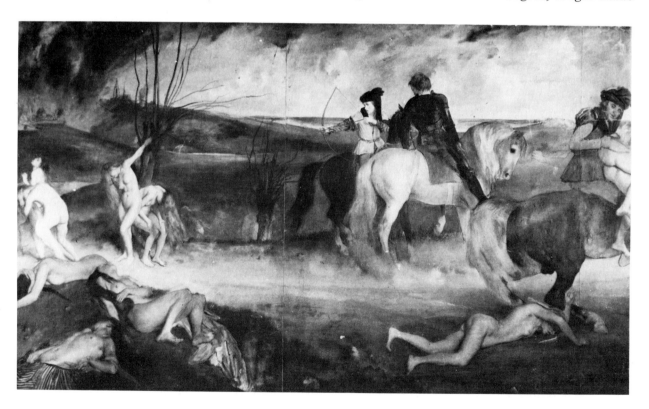

many preparatory studies, for various parts as well as for the designs as a whole. Of these early history pictures, *The Young Spartans* (Plate 3) is the most successful. The subject is a simple one: in ancient Sparta boys and girls exercised together, and in the painting the Spartan girls have just challenged the boys to a contest.

Degas spent a good deal of time on the work, making preliminary drawings for individual figures and altering the overall design more than once. But the 'correct' classical tone, lying somewhere between the slightly frigid mood of Ingres's own work and the adroit mixture of idealization and archaeology that was a sure recipe for official success as a painter in France throughout the nineteenth century, still eluded him. *The Young Spartans*, fortunately, is as little like a conventional nineteenth-century history picture as it is possible to imagine. The colour is as delicate and understated as the drawing. There are no hard lines, no rhetoric, and little or no evidence of archaeological research; instead an impression of casual everyday life, a subtle study of adolescence with its touching interplay of boldness, silliness, curiosity and shyness.

There is an earlier variant of the painting in existence, however, and it is more traditional in character. There is a Greek temple in the background and the girls have been given classical headgear and idealized profiles with straight noses. In the final version in the National Gallery (Plate 3) they have the snub noses of Parisian *jeunes filles*. What induced Degas, self-confessed admirer of Ingres and the classical tradition, to make so conspicuously informal an alteration?

The simplest answer would be to say an awareness of modern life. In April 1859 Degas had taken a studio in the Rue Madame in Paris. As well as historical subjects, he also began to paint portraits (the largest and most ambitious of all his essays in portraiture, *The Bellelli Family*, now in the Louvre, belongs to the late '50s and early '60s). In 1862, Degas met the painter Edouard Manet (1832–83), who was becoming increasingly interested in themes from modern life in preference to more traditional kinds of subject-matter. Degas also met Edmond Duranty (1833–80), a critic, novelist and friend of Manet. Duranty was a passionate believer in 'Realism', and was anxious to break down the barrier he felt existed between art and daily life. Degas was later to paint a superb portrait of him (Plate 33).

Degas soon became a familiar figure at the Café Guerbois, where many of the artists most closely associated with what became known, after 1874, as Impressionism were accustomed to meet and talk in the evenings. Degas's art began to reflect his changing views

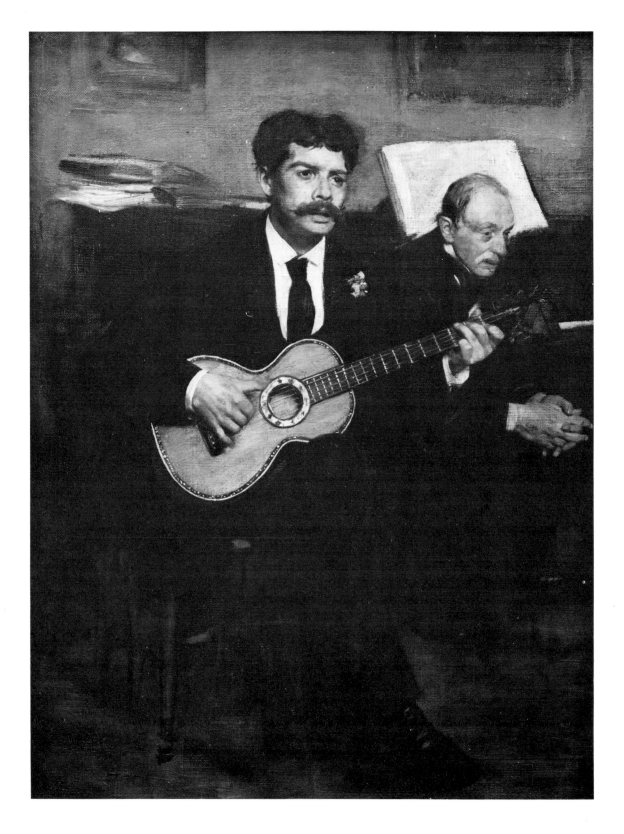

in the second half of the 1860s, when he gave up the historical genre and turned for inspiration to the racecourse (Plates 9 and 15) and the theatre (Plates 11 and 12). He continued to exhibit at the official Paris Salon until 1870. In the Franco-Prussian War (1870–1), Degas served in the Artillery; and it was after a severe chill contracted during this military service that his eyes first began to give him trouble.

But what exactly do we mean, and what might Degas have understood, by the phrase 'an awareness of modern life'? A number of things, related and combined: chiefly an unbiased attitude towards permissible subject-matter, so that a fascination with the small change of everyday life became strong enough to replace traditional, Old Master-ish themes as the proper diet for the creative imagination, and a growing desire to find a style, an angle of vision, in accord with the nature of the material. Degas's chief aim, throughout his career, was to make the spectator conscious, in wholly pictorial terms, of the quality of ordinary life; and at the centre of his art was a visual analysis of the human being, the human body, the way it sits, stands, walks and gestures, its grace (Plate 30), its weight (Plate 34), what it can be made to accomplish by training and discipline (Plates 17 and 31), what it may be forced to do through circumstance (Plates 35 and 38). Degas wanted to capture an illusion of life without distorting it in the very process of giving it a memorable aesthetic form.

The task was not made any easier by Degas's fundamental ambivalence towards the world in which he lived. Ingres did his best to forget that he was living in Paris in the nineteenth century. But it was precisely this fact that Degas could not forget. He may not have been pleased with modern life: 'they were dirty,' he once said of the era of Louis XIV, 'but they were distinguished; we are clean, but we are common.' Yet he came to accept it. His appetite for what was actual and real was simply too acute to remain satisfied with the trappings of the classical style. The toga, the Doric capital and the ageless legends of Antiquity might stand for sublime values and a nobler mode of being; but there was something shadowy about them, and like a ghost at cock-crow they faded in the glare of the gas jets that illuminated the streets, cafés and theatres of modern Paris.

But there are no railway trains or rolling mills in Degas's work. His attitude to contemporary life was never the arid token of a self-conscious philosophy, willing to see in every new-fangled piece of machinery the soul of the nineteenth century, but a natural and spontaneous effusion of his nerves, his sense of humour, his curiosity and his imagination. An excellent mimic, he developed an insatiable interest in behaviour, the seemingly trivial detail, the

Fig. 4
Portrait of Pagans with Degas's
Father

CANVAS, 54 × 39 CM. C.1869. PARIS, LOUVRE
(JEU DE PAUME)

11

sudden need to yawn (Plate 38), scratch one's back (Plate 19) or adjust a shoe (Plate 17). Degas was a brilliant observer of ordinary life, and it was this as much as his compositional devices or his attitude towards light that marks him out as a true Impressionist, to be ranked with Monet, Pissarro and Renoir.

These, then, were the two basic poles round which Degas's mind, his temperament and his artistic personality revolved: a feeling for modern life, and a sense of artistic tradition. But far from dividing his talent into two and reducing him to creative impotence, the rival claims grew together, nourishing his abilities and clarifying his perceptions, and like the different coloured lenses in a pair of toy glasses they enabled him to see his own art and the aesthetic situation of the day with stereoscopic clarity.

In a letter to a friend, Degas regretted that he had not lived at a time when painters, unaware of women in bath tubs, had been free to paint Susanna and the Elders. At the same time he sensed that the whole temper of the nineteenth century, with its materialism and stress on scientific investigation and the objective record, was subtly destroying the delicate balance between imagination and fact on which for centuries the success of historical and Biblical painting had depended. Religious art in the tradition established by Leonardo da Vinci, Michelangelo and Raphael could never survive topographically accurate records of the Holy Land.

Degas had a sharp and witty tongue and he spared no one, least of all his friends. He did not conceal from Gustave Moreau that he had no time for his highly detailed mythological and religious fantasies: 'He wants to make us believe the Gods wore watch-chains,' he was fond of saying. Under the pressure of strong aesthetic feeling, would not a love of beauty combine with archaeological exactitude to form a philosophy of ornament? One day Moreau asked Degas: 'Are you really proposing to revive painting by means of the dance?' Degas parried: 'And you, are you proposing to renounce it with jewellery?' He might also have been thinking of Wilde's *Salomé*. One can imagine what he would have thought of the Hollywood epics that reduce the Bible stories to so many yards of sequins and temple dancers.

The same degree of perception was brought to bear on the problem of portraying modern life. Degas soon realized that it was not enough to paint people in their ordinary clothes, while adopting a highly traditional type of composition, as he had done in his *Self-portrait* of about 1855 (Louvre), which had been based on a romantic Ingres *Self-portrait* of 1804 (Musée Condé, Chantilly). The whole strategy had to be thought out anew. Changing only the details was like introducing colloquial phrases into a play that was still in verse and meant to be performed in the grand manner.

But conversation in real life was full of half-finished sentences and overlapping talk. And was not the same true of appearances? It soon became very clear to Degas that what gives so many of life's actions their final seal of triviality is that they occur simultaneously. If the world had stopped and held its breath while the woman in the café took a sip from her drink (Plate 22), it would indeed have become an act to set beside the crowning of kings. But the world does not stop, it goes on, and the woman is barely noticed by the man smoking his pipe. One dancer yawns at precisely the same moment as another scratches the back of her neck (Plate 17); and both appear oblivious of the ballerinas who are actually dancing. The clerk works at his ledger — unaware of the man reading a paper, who in turn ignores his elderly colleague busy feeling the quality of the cotton (Plate 14). Simultaneous action was not a new idea in painting, but in the art of earlier centuries it had often been geared to religious or mythological illustration, where all the characters react in differing ways to a central event (Leonardo's *Last Supper* is the perfect example), or used as a means of illustrating a general idea ('the unruly school room', 'Gluttony', etc.) in an entertainingly varied manner. Degas stood the idea on its head, by choosing themes without a central dramatic point (the ballet *rehearsal* rather than the full-scale performance, the horses on the

Fig. 5
Sulking ('Bouderie')

OIL ON CANVAS, 32.4 × 46.4 CM. C.1875. THE METROPOLITAN MUSEUM OF ART (BEQUEST OF MRS H. O. HAVEMEYER, 1929. THE H. O. HAVEMEYER COLLECTION)

13

track rather than the race itself) and by adopting an angle of vision that reduces the significance of the event (the café singer seen, as if by chance, above and beyond the obtrusive outline of orchestra and audience — Plate 25).

Trivial events, gestures and movements, the sigh of weariness (Plate 38), the pressure of the hand on the iron (Plate 35), an habitual pose with the face resting against the hand (Plate 33), the singer in full song, black-gloved hand expressively poised (Plate 29) — they were all real enough, but were they compatible with art? Degas thought they were, though the same analytic cast of mind that led him to probe deeply into the problems of naturalistic representation made him unusually conscious of the dangers to which naturalism so easily gives rise. Unlike certain modern artists, Degas never imagined that one might achieve an even greater degree of realism by breaking through the very barriers of style itself. 'One sees as one wishes to see,' he once remarked, 'and it is that falsity that constitutes art.' The philosophy of a Marcel Duchamp would have shocked and bewildered him.

Nor did Degas imagine that naturalism would immeasurably broaden the scope of art. The apparent variety that it seemed to imply was really a symptom of its greatest potential weakness, triviality. Degas was only too well aware of the trap into which so many popular artists fell in their never-ending search for novel subjects to please a public that was frivolous and easily bored. 'Instantaneousness is photography, nothing more,' we find him writing in a letter of November 1872. A few days later, in a letter to his friend Henri Rouart, he expressed the view that 'one loves and gives art only to the things to which one is accustomed. New things capture your fancy and bore you by turns.' He touched on the point again in a letter written in January 1886 to Bartholomé: 'It is essential to do the same subject over and over again, ten times, a hundred times. Nothing in art must seem to be accidental, not even movement.'

Like the Renaissance artists whom he so much admired, Degas believed in the perfectibility of a visual idea. Through study, analysis and repetition an image could be made stronger and more inevitable; everything must be made to seem necessary both to the vision and to the design. At the real Café des Ambassadeurs what would have been important would have been the performance on the stage. The fact that the top of the double-bass was visible over the heads of the orchestra should have been totally irrelevant; it was not what one had paid to see; though one might have been marginally, almost subliminally, aware of it. Degas seized on just this point: what might be irrelevant to a scene, judged by conventional and in many respects artificial standards, could actually be

used as a hallmark of its truth to life. And so, in the painting (Plate 25), the top of the double-bass is given a key position in the design, its curves in visual harmony with the shape of the singer's red skirt. In a similar way, in a famous series of paintings of ballet performances seen from the vantage point of the front stalls, Degas wittily challenged the notion that audiences sit through a performance in rapt attention by showing people looking through opera glasses at the boxes. Degas went to the opera, ballet and theatre frequently, and he knew perfectly well that the artistry the performers laboured to perfect (Plates 11, 16, 17, 19, 28 and 44) was often thrown away on customers who were bored, restive or ignorant, and who had gone in the first place because it was the thing to do or because they wanted to catch a glimpse of the dancers' legs.

To Degas, with his traditional training and admiration for the wholeness of Renaissance art, its complexity concealed beneath a unified surface, it became very clear that 'irrelevance' could only be made to work, artistically, if it was seen to be essential to the conception and design of the work of art. The *Portrait of Estelle Musson De Gas* (Plate 13) seems particularly 'true to life' because the features have been accurately recorded and because the design is dominated, not by the figure of the lady, the ostensible subject of the picture in the first place, but by the obtrusive but none the less visually effective vase of flowers on the right.

Some of Degas's earlier naturalistic works, such as *The Dance Foyer at the Opéra, Rue Le Peletier* (Plate 11), *The Ballet Rehearsal* (Plate 17) or *The Cotton Market* (Plate 14), while brilliantly painted and rich in well-observed detail, are slightly over-full. Later pictures are less crowded, and Degas makes greater play with fewer motifs, as may be seen by comparing the trio just listed with the *Two Laundresses* (Plate 38), *The Millinery Shop* (Plate 39) or almost any of the late Bathers (Plates 36 and 41–3). He even used an empty floor or patch of ground as a visual symbol of irrelevance; this explains the undue prominence given to the stage in Plate 18 and to the grass in Plate 32.

Always at the back of Degas's mind was a precise combination of lines and colours, and arrangements of form, that would combine the firmness and inevitability of classical design, the basis of Greek and Roman art and the painting of Raphael and Leonardo, Titian and Poussin, with an impression of life that was immediate and spontaneous. Degas devoted a very large part of his career to the difficult task of preserving the disciplines and poised effects of the best kind of traditional art while rejecting its time-honoured associations, props and subject-matter. Paul Cézanne once said that he wanted to make of Impressionism something solid and durable,

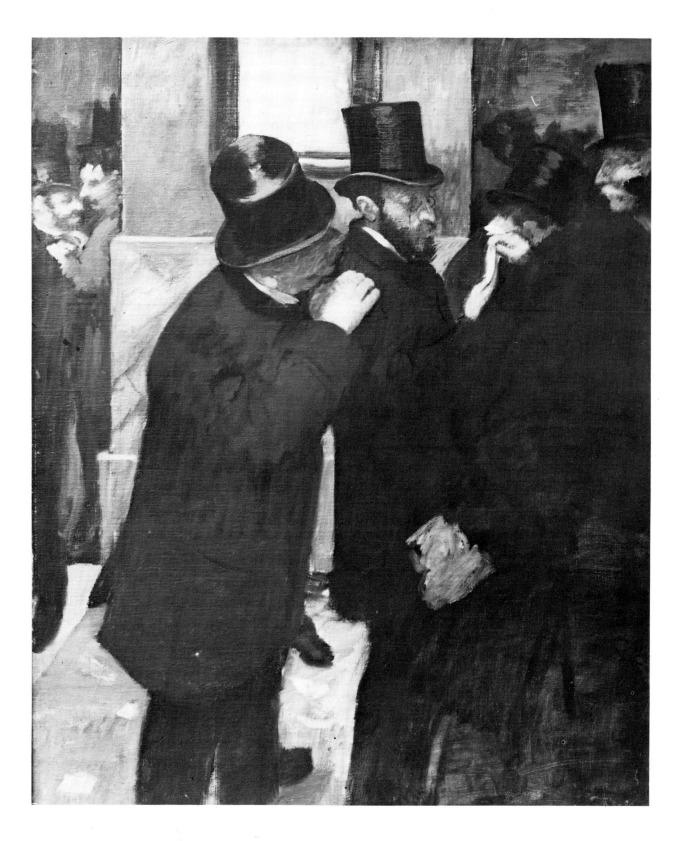

like the art of the museums. Degas would have agreed with him. Characteristically, he summed up his position in an epigram: 'Ah, Giotto, don't prevent me from seeing Paris; and Paris, don't prevent me from seeing Giotto.'

In an earlier century, the female figure hovering in the air, and seen from below, would probably have been the Virgin Mary at the moment of her Assumption. In Degas's composition (Plate 31), which is contrived with all the skill and artistry of an Old Master, she is a circus performer swinging by her teeth. And nothing could be less obviously idealized, less like the figures of Ingres in fact, than Degas's studies of the female nude (Plates 36, 41, and 43). The artist himself told the Irish writer George Moore that they represented 'the human beast occupied with herself, a cat licking herself', and they create a realistic impression because we are shown women who have undressed not for our admiration but to wash their bodies. The comparison with Renoir is instructive. In his nudes, Renoir usually shows the face, which is the key to intimacy, and his lusciously pretty girls even look invitingly at the spectator (Fig. 33). Degas avoids the face and usually prefers a back view of the figure, thus heightening the illusion of a true-to-life glimpse. The sense of actuality is increased by compositional devices, the view through an open door, perhaps, or the choice of an unusual angle (Plates 36 and 43).

Renoir painted away, year after year, and his skill and love of life, his vulgarity and dreamy optimism, the erratic drawing and faulty space composition, the weakness for rainbow colours, they are all right there on the canvas. Nothing has been held back, there is nothing in reserve; even with the major paintings you are made to feel that this is absolutely the very best he could do. But study a large body of Degas's work for any length of time and a different impression forms. Degas burrowed deep, he was in many ways a very experimental artist, but his achievements have a carefully calculated air of anonymity. The talent and skill seem somehow masked so that, even in elaborate pictures (Plates 3, 4, 11, 14, 16, or 17, for example), he never appears to be at absolutely full stretch. Like Leonardo, Degas suggests a mastery that goes far, far deeper than anything that can actually be seen on the surface and yet which seems to control, as from a great distance or great height, every detail of what is there on paper or canvas. Renoir went from canvas to canvas and, if it was a good day, a good painting would emerge, but one seldom senses any purpose larger than the context of the moment. With Degas, however, working away on the same limited number of themes (landscape, still-life, flowers and animals, apart from horses, rarely appear in his work), and using the same figures in the self-same poses over and over again, one has an

Fig. 6
'A La Bourse'
CANVAS, 100 × 82 CM. 1879. PARIS,
MUSÉE D'ORSAY

impression of long-range planning and iron determination. There are times, indeed, when Degas's enormous œuvre almost seems like the preparation for some heroic undertaking that never actually materialized.

It was this strange and impressive artistic sensibility, precariously poised between an aesthete's disgust and passionate curiosity about life, that Degas brought to the time-honoured theme of the female nude. Without sacrificing one jot of their everyday ordinariness, he was able to invest the bodies with the monumentality of ancient sculpture; his figures have that sense of being individual and yet, at the same time, impersonal, which is a hallmark of so much Antique art. Renoir once compared these works (Plates 36, 41 and 43) to fragments from the Parthenon, the noblest creation of fifth-century Athens.

In art observation will go for nothing unless it is related to design. And it was this underlying discipline of classical design that Degas so admired in the paintings of Ingres. He never allowed himself to forget the lesson of Ingres. It was constantly, vitally relevant, precisely because his own kind of naturalism was so radical, committed to showing not only what is actual and unidealized (seventeenth-century Dutch painters had already done this) but also how it *appears* to the eye (which few Dutchmen had attempted). So far-reaching a proposition raised, and still raises, the question of what is meant by 'true to life' and how 'casual' and 'significant' should be defined. When, in daily life, we notice something 'casually', we make a lightning judgement according to standards of what is significant. For any one of a thousand accidental reasons, other people's lives impinge upon our own; we are made aware of a gesture, a movement, a figure, and just for a moment it occupies the forefront of our attention. But we soon dismiss it again if it does not pass the test of what is personally important to us. A woman in black, kneeling in prayer, with tears streaming down her face, is likely to make a deep impression because she brings to mind profound associations of death and loss. And she might also stand, incidentally, for a type of recognizably emotive image favoured by the older and more traditional schools of art. But a woman merely yawning (Plate 38), a man smoking a pipe and evidently thinking about something else (Plate 22) or a girl leaning over a table and resting her body on her crossed arms in a pose that every single human being must have adopted at some moment (Plate 37), they are all visual phenomena too ordinary to lodge themselves in the memory; and they merely take their place in the passing flow of impressions which make up the richly varied yet curiously vague texture of daily life.

Degas's great achievement lay in his ability to render that texture in wholly pictorial terms. The life-like casualness of his 'impressions' is defined not through implicit appeals to our non-pictorial faculties of judgement, as it is in Victorian anecdotal painting, where even the titles (*The Morning Gossip, A Passing Thought*) stress the story, but by pure design. On the right of *The Rehearsal* (Plate 16), the wardrobe-mistress is repairing or adjusting the skirt of a dancer. It is an action of no intrinsic importance; and that is what, by virtue of his art, Degas allows it to remain. The instinctive human process of attention, judgement and dismissal is transmuted into a pictorial device, whereby the group is deliberately cut into by the edge of the picture. Move the whole group to the centre of the canvas and it would assume, because of its dominant position in the design, a 'non-casual' importance; and the pictorial situation might become pregnant with just those narrative implications that Degas wanted to avoid.

There are of course difficulties. The kind of impersonality that Degas achieved goes against what many people want from art, it is the enemy of what is cosy and friendly, touching and pretty, and it is not surprising that his work has been misinterpreted in the usual kind of terms that people are still accustomed to apply to works of art. '*L'Absinthe*' (Plate 22) was violently attacked in the 1890s for its alleged obscenity, as if it had been deliberately created to shake people out of their complacency, like Ibsen's *Ghosts*, whereas in reality it is a painting of a couple in a Parisian café, the woman merely lost in thought. And the very fact that Plate 37 has always been known as '*The Reading of the Letter*' is a minor example of the same literary, dramatizing principle at work. For what is surely happening in the picture is that two laundresses are having a rest, and one of them is cooling herself with a makeshift fan. Plate 37, like so many of Degas's works, is not about a significant event but about physical behaviour. And design, with all its implications of selection and emphasis, is at the centre of Degas's achievement. For it enabled him, at one and the same time, to re-create an impression of unaccented, flowing life and to preserve a purely aesthetic harmony that is not haphazard at all — and without which the very power of the vision would be lost. Degas created unforgettable images of unmemorable facts; and in this light his art, representing as it does a tolerant acceptance of life, takes on a moral dimension.

Degas's life was not in itself very eventful. He had private means and did not need to court either popularity or customers. He never married. Between October 1872 and April 1873 he was in America, visiting his brothers in New Orleans; the most important artistic

result of the trip was the painting of the New Orleans Cotton Exchange (Plate 14). On his return to Paris Degas settled in a studio in the Rue Blanche, where he concentrated on themes from modern life, often connected with some form of professional skill: dancers, acrobats (Plate 31), jockeys (Plate 15), singers (Plates 25 and 29), musicians (Plate 12), milliners (Plate 39) and laundresses (Plates 35, 37 and 38). To this list he soon added the female nude, which became, with dancers, his favourite subject-matter in later years.

To the group show mounted by the Impressionists in 1874 Degas contributed ten works; and he exhibited at all the others, save for that of 1882. In 1881 he showed the *Little Dancer of Fourteen Years* (there is a cast in the Tate Gallery), the only one of his sculptures exhibited in his lifetime. After 1886, the year of the eighth and last Impressionist group exhibition, Degas stopped sending works to public shows. His eyesight was by now very poor, and he worked more and more in pastel, a medium he found susceptible to bolder effects than oils.

Degas was concerned with the underlying structure of design and form from the very beginning. Already, in 1856, we find him writing in a note-book: 'It is essential, therefore, never to bargain with nature. There is real courage in attacking nature frontally in her great planes and lines, and cowardice in doing it in details and facets.' Even when copying the great artists of the past, as an exercise, Degas was faithful to his maxim, blocking in the forms broadly and ignoring minute details. *The Young Spartans* (Plate 3), or a portrait like the *Estelle Musson De Gas* (Plate 13), reveal the same approach to form. And it is also evident in the double portrait of the artist's sister, Thérèse, and her Italian husband, Edmondo Morbilli, whom she married in 1863 (Plate 6). The picture was probably never finished; and the disfiguration across the woman's body was no doubt caused by Degas scraping away what he had done in dissatisfaction.

The composition of the portrait is of great interest in that it shows one of the ways in which Degas attempted to reconcile harmonious classical design with the conclusions that he made from his observation of actual behaviour. Thérèse Morbilli sits conventionally enough at one end of an Empire sofa in an ordinary sitting-room; but her husband casually balances on the back of the sofa, turning to look, as she does, in the direction of the spectator. The pose would have been thought much too informal and precarious by traditional portraitists, but these were precisely the qualities that Degas prized for their life-giving values. The increasing vitality and imaginative force of Degas's portraiture may

Fig. 7
The Dance Lesson

PASTEL ON PAPER, 67 × 59 CM. 1879. NEW YORK, METROPOLITAN MUSEUM OF ART (THE H. O. HAVEMEYER COLLECTION)

20

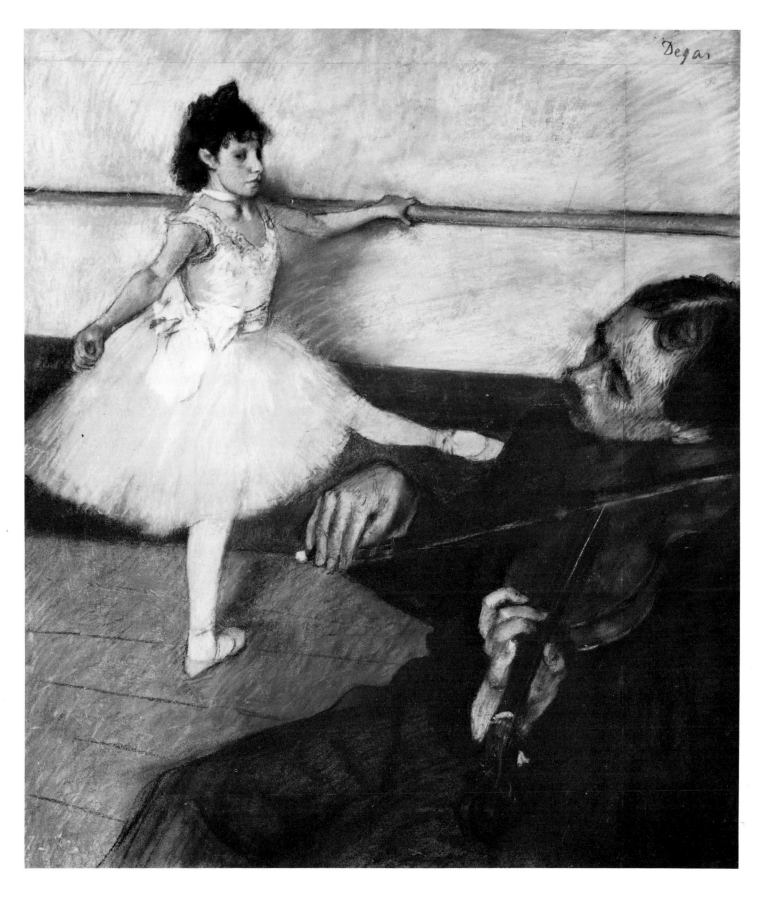

be judged by a simple comparison between the very early picture of Achille De Gas (Plate 1), formally posed against an almost neutral background, and the two very important 1879 portraits of champions of the new painting, Diego Martelli (Plate 34) and Edmond Duranty (Plate 33), shown in ordinary working clothes in their own environment. Both are masterpieces of calculated informality. Even the much earlier picture of the Morbillis has an immediacy alien to a portraitist like Ingres, the suggestion of people suddenly asked, in the middle of the afternoon, to look in the artist's direction for a minute or two while he paints them.

In working out formulae that would accommodate this spontaneous fragmentary aspect of vision, Degas was influenced by Japanese prints, which had become both popular and fashionable in the early 1860s, and by developments in photography. From the colourful prints of Japan, he learned how to cut off the figure abruptly (for example, the man on the right in Plate 27 or the dancer on the right in Plate 16); how to achieve effects through calculated asymmetry (Plates 18, 31 and 32); and how to make use of the bold close-up (Plate 29). The sloped foregrounds in his work (Plates 18, 32 and 34) and unusual sight angles (Plates 12 and 26) suggest the influence of photography, an art in which Degas was himself a proficient amateur.

Visual spontaneity, however, was not achieved at the expense of visual equilibrium. Again under the impact of Japanese prints, which do not conform to Western traditions of box perspective, Degas learned to use void areas positively. The grass in the *Jockeys before the Race* (Plate 32), for example, or the boarded floor in *The Rehearsal* (Plate 16), even the table tops in *'L'Absinthe'* (Plate 22), tell not only as surface receding into depth but also as flat shapes whose very simplicity is a counterweight to the figures.

The crucial link between the flux of life and the unfluctuating sense of order that Degas felt was proper to art lay in design, which in turn depended on drawing — the lines, the many lines Ingres had urged him to draw.[Degas shared the general Impressionist interest in the effects of light, and he could render them with the greatest delicacy and precision (Plates 9, 16, 18 and 29); he knew the value of light, and how it could be made to reveal form (the arms of the singer, for example, in Plate 25) and emphasize movement (Plate 20), but he would never allow the observation of light to undermine the importance of drawing] Even when the forms are seen under a powerful illumination, the outlines in Degas's paintings are always firmer than those of Monet, Renoir or Pissarro. And Degas would make preliminary sketches of figures which, in the final painting, might be subjected to entirely different methods of lighting. For *The Rehearsal* (Plate 16) four beautiful drawings

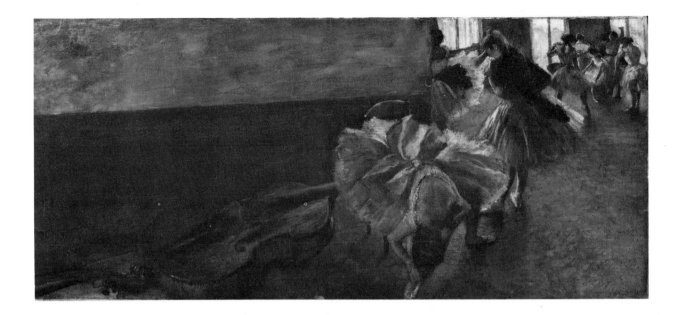

Fig. 8
Dancers in the Rehearsal Room
with a Double-bass

CANVAS, 40 × 90 CM. 1887. NEW YORK,
METROPOLITAN MUSEUM OF ART
(THE H.O. HAVEMEYER COLLECTION)

have survived; and in some even a plumb-line was used. To describe a painting like this as a 'slice of life' created with the patient subterfuge of the Old Masters is to underline what the artist once told George Moore: 'No art was less spontaneous than mine. What I do is the result of reflection and study of the great masters; of inspiration, spontaneity, temperament, I know nothing.'

A feeling for order depends on having a sense of priorities arrived at through evaluation. Drawing was Degas's method of evaluation. Pastel always appealed to him precisely because it enabled him to retain colour without giving up a linear emphasis. In one of his most illuminating remarks, Degas explained why it was important that the artist should not draw only what was directly in front of him. 'It is all very well to copy what you see,' he said, 'but it is much better to draw only what you still see in your memory. This is a transformation in which imagination collaborates with memory. Then you only reproduce what has struck you, that is to say the essential, and so your memories and your fantasy are freed from the tyranny which nature holds over them.' Degas is one of the great draughtsmen in the history of European art, and the constant exercise of this great gift on a restricted range of subject-matter enabled him to judge, with increasing sureness, what could and could not be eliminated in any sequence of forms. The girl combing her hair, on the left of Plate 21 (about 1875–6), is an exquisitely observed figure: look at the placing of the hands and arms, and the way in which the head is forced slightly to one side by the downward pressure of the comb drawn through the hair. Yet the study remains highly simplified. The tiny irregularities, the bumps, veins and wrinkles in hand and arm have been suppressed. But it is precisely this careful selection of the forms which gives to those that are finally included their conviction and simple grandeur. *Combing the Hair* (Plate 45) dates from about fifteen years

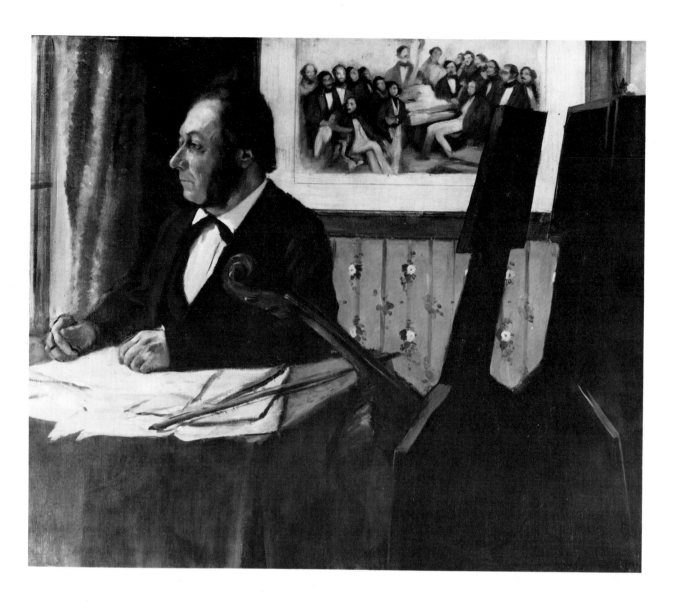

Fig. 9
Portrait of the Violoncellist,
Pillet

CANVAS, 50.5 × 61 CM. 1868–9. PARIS,
MUSÉE D'ORSAY

later and it carries the process of monumental simplification a stage further. So sure is the drawing that the image seems naturalistic even though the colouring is highly artificial.

Degas also valued drawing because line and outline are among the most satisfactory methods of creating an illusion of movement — the movement on which he always concentrated because for him it vividly expressed the pulse-beat of life. True to the Impressionists' anti-literary doctrine, Degas tried to achieve the maximum expressiveness of form and complexity of movement with the minimum of narrative association. The paintings inspired by the ballet — the most popular and in some respects the least understood category of his work — exemplify his aims; and a copy that he made about 1870 in the Louvre of Poussin's *Rape of the Sabine Women* (about 1635–7) helps to make the point even more clearly.

In the Poussin copy, across a setting that is itself not unlike the stage of a theatre, carefully placed groups of figures display the

whole gamut of emotions implied by a concerted attack. Degas himself, in his maturity, did not paint such a scene. But in the dancer, the laundress, the jockey, the acrobat, the milliner arranging her hats, the woman at her toilet, he found a corresponding range of bodily movement. He was particularly attracted by the exercise of a professional skill in which highly conscious and often severely disciplined actions were brought into play for professional rather than personal reasons. As she pirouettes and glides across the stage, and raises her expressive arms, the dancer is not Daphne eluding the amorous Apollo or a Sabine resisting her earnest captor; but neither is she a dramatic character in a ballet; she is simply a dancer doing her job. In one complex operation, Degas, like Daumier in his theatrical scenes, preserves the trappings or artifice while stripping away the pretence.

Of all the painters loosely grouped together under the name of Impressionists, Degas most deserved a great final phase of creative activity. But though he laboured on, he was denied through failing sight an ultimate flowering of his great gifts. The last twenty years of his life were wretched. His eyesight deteriorated still further in the 1890s; and in the early years of the new century he could only work, and then with difficulty, on large compositions or sculpture that he could model with his hands, by touch. In 1908 he more or less gave up art altogether. The blow was crippling. Degas's life was over. But he went on living, morose, irritable, pathetic, endlessly repeating his old maxims and anecdotes and falling into terrible silences broken by a single utterance: 'Death is all I think of.' Long famous and revered, he died in Paris on 27 September 1917.

The qualities of mind that had helped to make his artistic achievements so exceptional made his last years particularly tragic. As the once sure hand, as sure as any since Leonardo da Vinci, Holbein or Rembrandt, fumbled with the chalks, no wonder he railed at fate. He knew, so clearly, what he wanted to do. Unable to do it, his life became barren, aimless, a terrifying fog illuminated only by the glimmer of memories. As he shuffled along the boulevards 'in his Inverness cape, tapping his cane, feeling his way', oblivious to the sounds of the motors and frequently in danger of being run over, how often his mind must have gone back over half a century to that unforgettable meeting with another great artist, then also old, and to the advice he had given: 'Draw lines, young man, many lines...'

Outline Biography

1834 Born in Paris, 19 July, son of a banker.

1845–52 At school in Paris (Lycée Louis-le-Grand).

1852–4 Begins to study art seriously, under Barrias and Lamothe.

1854–9 Regular visits to Italy, where he studies and copies Renaissance and ancient art. In Rome, in touch with the French Academy there.

1859 Takes a studio in the Rue Madame, Paris, and concentrates on portraiture and historical subjects.

1865–70 Contributes regularly to the official Paris Salon (French equivalent of the Royal Academy).

1870 Serves in the Franco-Prussian War. By this date, he is already painting such 'modern' subjects as theatre and orchestra scenes as well as horses and jockeys.

1872–3 Visits his brothers in New Orleans and paints several pictures there, notably *The Cotton Exchange* (Plate 14).

1874 Contributes to the first Impressionist Exhibition in Paris; and to all the others, with the exception of the 1882 show.

1880 Visit to Spain.

1886 Contributes to the last Impressionist Exhibition. After this date, he does not send his work to public exhibitions, though his pictures are shown commercially by Durand-Ruel. By this date his eyesight is very poor and he is working more and more in pastel.

1889 Visits Spain with the painter Boldini.

1912 By this date Degas has become famous and his works relatively popular. *La Danseuse à la Barre* (New York, Metropolitan Museum of Art) fetches $100,000 at auction.

1917 Dies in Paris, 27 September.

Fig. 10
Self-portrait

ETCHING, 23 × 14 CM. 1857. FORT WORTH,
KIMBELL ART FOUNDATION

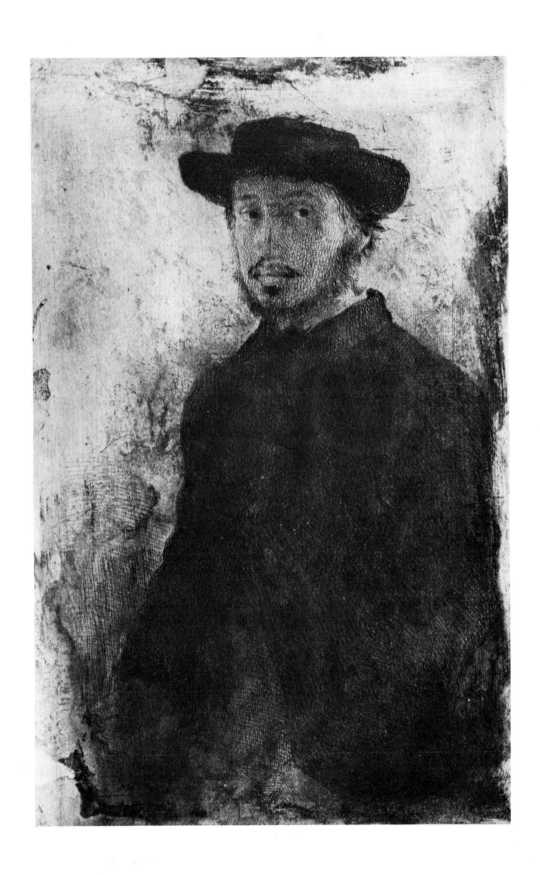

Select Bibliography

Adhémar, J. and Cachin, F., *Edgar Degas, gravures et et monotypes*, Paris 1973.

Boggs, J.S., *Portraits by Degas*, Berkeley and Los Angeles 1962.

Browse, Lillian, *Degas Dancers*, London 1949.

Burlington Magazine, June 1963; special issue on Degas.

Cooper, Douglas, *Pastels by Degas*, New York 1953.

Guérin, Marcel (ed.), *Lettres de Degas*, Paris 1945, trans. by Marguerite Kay, Oxford 1947.

Dunlop, Ian, *Degas*, London 1979.

Halévy, Daniel, *My Friend Degas*, trans. and ed. with notes by Mina Curtiss, Wesleyan University 1964 and London 1966.

Janis, E.P., *Degas Monotypes*, Cambridge, Mass. 1968.

Lemoisne, P.A., *Degas et son oeuvre*, 4 vols., Paris 1946.

Pool, Phoebe, *Degas*, London 1968.

Reff, Theodore, *Degas: The Artist's Mind*, New York 1976.

Reff, Theodore, *The Notebooks of Edgar Degas*, 2 vols., Oxford 1976.

Rich, D.C., *Edgar-Hilaire-Germain Degas*, New York 1951.

Rouart, Denis, *Degas à la recherche de sa technique*, Paris 1945.

Valéry, Paul, *Degas Danse Dessin*, Paris 1936, trans. by David Paul in *Degas Manet Morisot*, New York 1960.

EXHIBITION CATALOGUES

Ronald Pickvance, *Degas 1879*. An exhibition organized by the National Galleries of Scotland and the Edinburgh Festival Society in collaboration with the Glasgow Museums and Art Galleries. National Gallery of Scotland, September 1979.

Ronald Pickvance, *Degas's Racing World*. Catalogue of the exhibition held at Wildenstein's, New York, March to April 1968.

List of Illustrations

Colour Plates

1. Achille De Gas in the Uniform of a Cadet
 CANVAS. C. 1855 WASHINGTON, NATIONAL GALLERY OF ART (CHESTER DALE COLLECTION)

2. A Roman Beggar Woman
 CANVAS. 1857. BIRMINGHAM, CITY MUSEUM AND ART GALLERY

3. The Young Spartans
 CANVAS. C. 1860. LONDON, NATIONAL GALLERY

4. Semiramis Building Babylon
 CANVAS. 1861. PARIS, LOUVRE (JEU DE PAUME)

5. Woman with Chrysanthemums
 PAPER ON CANVAS. 1865. NEW YORK, METROPOLITAN MUSEUM OF ART (H.O. HAVEMEYER COLLECTION)

6. Duke and Duchess of Morbilli
 CANVAS. C. 1865. WASHINGTON, NATIONAL GALLERY OF ART (CHESTER DALE COLLECTION)

7. Portrait of James Tissot
 CANVAS. 1868. NEW YORK, METROPOLITAN MUSEUM OF ART

8. Interior
 CANVAS. 1868–9. PHILADELPHIA, HENRY P. MCILHENNY

9. Race Course Scene, with Jockeys in front of the Stands
 CANVAS. 1868. PARIS, LOUVRE (JEU DE PAUME)

10. Madame Camus
 CANVAS. C. 1869–70. WASHINGTON, NATIONAL GALLERY OF ART (CHESTER DALE COLLECTION)

11. The Dance Foyer at the Opéra, Rue Le Peletier (detail)
 CANVAS. 1872. PARIS, LOUVRE (JEU DE PAUME)

12. The Musicians in the Orchestra
 CANVAS. C. 1872. FRANKFURT, STÄDELSCHES KUNSTINSTITUT

13. Portrait of Estelle Musson De Gas
 CANVAS. 1872. PARIS, LOUVRE (JEU DE PAUME)

14. The Cotton Market
 CANVAS. 1873. PAU, MUNICIPAL MUSEUM

15. Horses on the Course at Longchamp
 CANVAS. C. 1873–5. BOSTON, MUSEUM OF FINE ARTS

16. The Rehearsal
 CANVAS. 1873–4. THE BURRELL COLLECTION – GLASGOW MUSEUMS & ART GALLERIES

17. The Ballet Rehearsal
 CANVAS. C. 1873–4. PARIS, LOUVRE (JEU DE PAUME)

18. Two Dancers on the Stage
 CANVAS. 1874. LONDON, COURTAULD INSTITUTE GALLERIES

19. The Dancing Class
 CANVAS. 1874. PARIS, LOUVRE (JEU DE PAUME)

20. Dancer Posing for a Photographer
 CANVAS. 1874. MOSCOW, PUSHKIN MUSEUM

21. Girls Combing their Hair
 PAPER. 1875–6. WASHINGTON, THE PHILLIPS COLLECTION

22. 'L' Absinthe'
 CANVAS. 1876. PARIS, LOUVRE (JEU DE PAUME)

23. Beach Scene
 PAPER MOUNTED ON CANVAS. 1876–7. LONDON, NATIONAL GALLERY

24. Carlo Pellegrini
 WATERCOLOUR, PASTEL AND OIL ON PAPER. 1876–7. LONDON, TATE GALLERY

25. Café-Concert at the 'Ambassadeurs'
 PASTEL OVER MONOTYPE ON PAPER. C. 1876–7. LYONS, MUSEE DES BEAUX-ARTS

26. Dancer with a Bouquet Bowing
 PASTEL ON PAPER. C. 1877. PARIS, LOUVRE (JEU DE PAUME)

27. Amateur Jockeys on the Course, beside an Open Carriage
 CANVAS. C. 1877–80. PARIS, LOUVRE (JEU DE PAUME)

28. Dancers Rehearsing
 PASTEL AND CHARCOAL ON PAPER. C. 1878. PRIVATE COLLECTION

29. Café Singer
 PASTE. ON CANVAS. C. 1878. CAMBRIDGE, MASSACHUSETTS, FOGG ART MUSEUM

30. Dancer on the Stage
 PASTEL ON PAPER. 1878. PARIS, LOUVRE (JEU DE PAUME)

31. La La at the Cirque Fernando, Paris
 CANVAS, 1879, LONDON, NATIONAL GALLERY

32. Jockeys before the Race
 CARDBOARD. C. 1879. BIRMINGHAM, BARBER INSTITUTE OF FINE ARTS

33. Edmond Duranty
 DISTEMPER, WATERCOLOUR AND PASTEL ON LINEN. 1879, THE BURRELL COLLECTION – GLASGOW MUSEUMS & ART GALLERIES

34. Portrait of Diego Martelli
 CANVAS. 1879. EDINBURGH, NATIONAL GALLERY OF SCOTLAND

35. Woman Ironing
 CANVAS. C. 1880. LIVERPOOL, WALKER ART GALLERY

36. After the Bath
 PASTEL ON PAPER. C. 1883. PRIVATE COLLECTION

Text Figures

Comparative Figures

Achille De Gas in the Uniform of a Cadet

CANVAS, 64.5 × 46.2 CM. C.1855. WASHINGTON, NATIONAL GALLERY OF ART (CHESTER DALE COLLECTION)

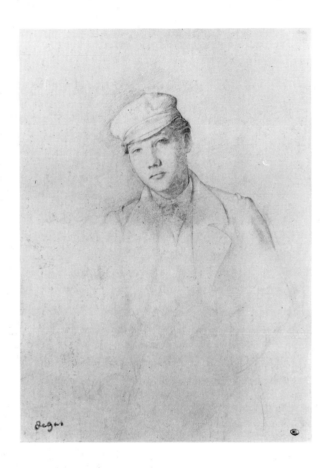

Achille De Gas was born in 1838 and this portrait was probably painted when he was eighteen, before Degas's journey to Italy in 1856. The most accomplished of Degas's early works are self-portraits, and drawings and paintings of his brothers and sisters. They share a combination of sadness and aristocratic reticence that is apparent in this portrait of Achille, despite the highly finished splendour of his cadet's uniform. The influence of Ingres is apparent, and the painting was preceded by a precise and delicate pencil-study (Fig. 11), on the verso of which is a drawing of Degas's youngest brother René. Dr Boggs has drawn attention to the fact that by this date Degas had also made copies of works by Franciabigio and Bronzino, and his early portraits suggest his response to the formality and disturbing melancholia of some Mannerist works.

Fig. 11 (left)
Portrait of Achille De Gas

PENCIL, 26.7 × 19.2 CM. C.1855. PARIS, LOUVRE

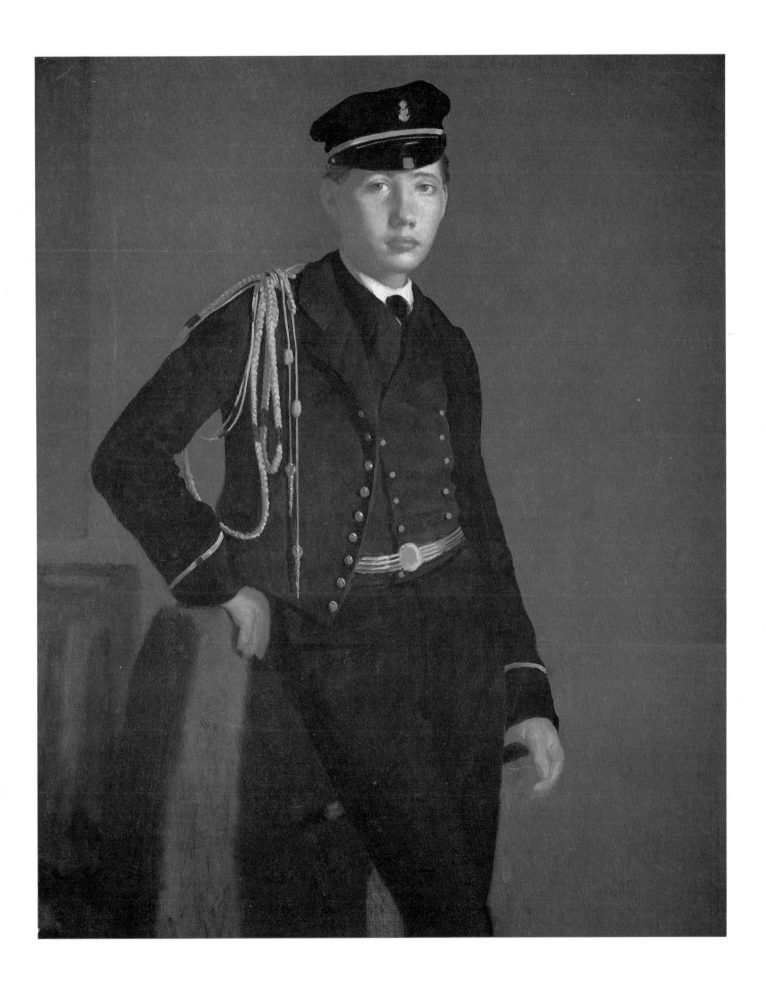

A Roman Beggar Woman

CANVAS, 100.25 × 75.25 CM. 1857. BIRMINGHAM, CITY MUSEUM AND ART GALLERY

This is one of the earliest of Degas's surviving works, painted during the five years that he spent in Italy, mostly in Rome, Naples, and Florence. Degas had no formal connection with the French Academy, but he made friends there, and worked there, adopting the French practice of making academic studies from life. Phoebe Pool has suggested that his interest in genre may have been stimulated by Victor Schnetz, the Director of the French Academy, who encouraged an interest in Italian popular life. This gravely dignified painting of an Italian beggar woman is unexpectedly assured and already looks forward to some of Degas's major preoccupations. In particular, the placing of the figure with its mass off-centre, and the sitter's unawareness of the spectator are features that will constantly recur in Degas's search for effects of spontaneity and informality. The use of paint is rather dry, but the drawing reveals Degas's study of Ingres, whom he was to revere all his life. French Realists of the 1850s and 1860s were attracted by similar subjects, but Degas's observation is already more dispassionate. His other, more picturesque studies of Italian peasants from this period have a charm close to Corot, and it has been suggested that the *Old Italian Woman with a Yellow Shawl*, whose air of melancholy resignation is reminiscent of Le Nain, is a copy from the Italian painter of beggars, Ceruti. These paintings are evidence of the breadth of Degas's interests. An intensive study of the Old Masters is complemented by a study of the life around him; the notebooks reveal a mixture of academic studies and copies and sketches of people and scenes that he saw on his travels.

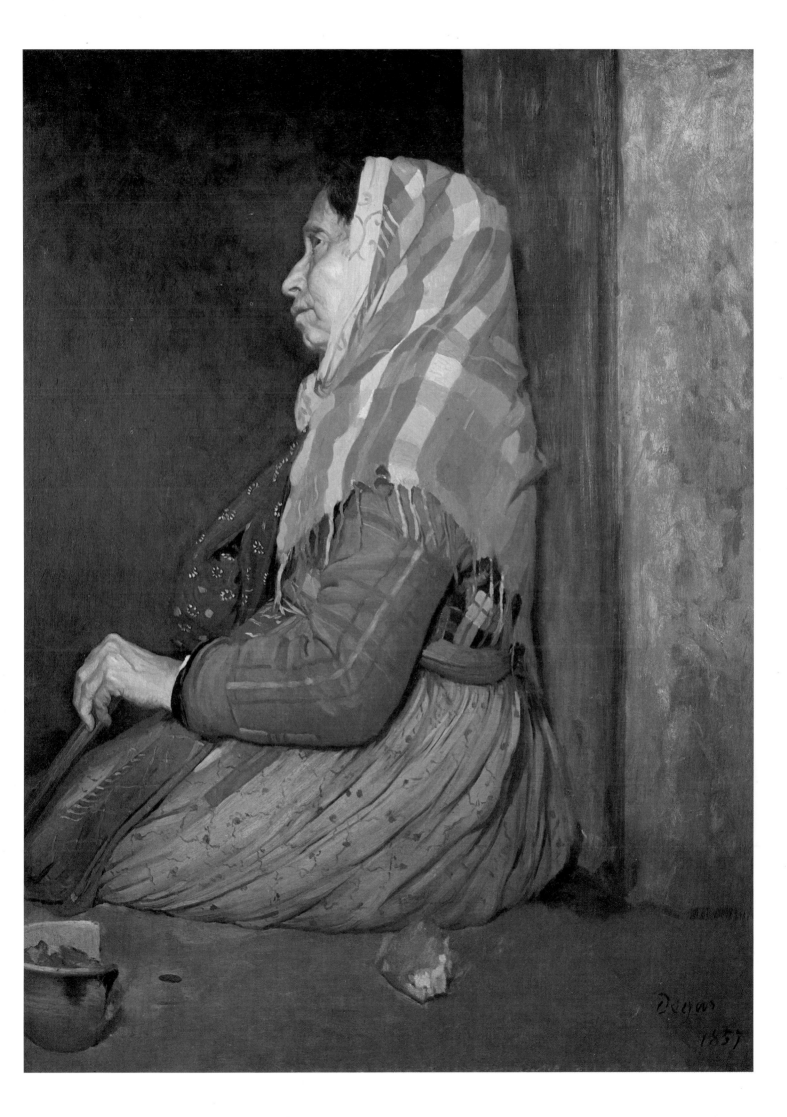

The Young Spartans

CANVAS, 109 × 154.5 CM. C.1860. LONDON, NATIONAL GALLERY

Between 1859 and 1865 Degas painted five important history pictures, all of which were carefully planned in a series of drawings and oil-sketches. The subject of this picture is taken from Plutarch's *Life of Lycurgus*. The Spartan girls are challenging the boys to fight; in the background are Lycurgus, the lawgiver, and the mothers of the children. Theme and composition are traditional, but the treatment is strikingly naturalistic. The figures have none of the ideal beauty of classical art, but a tough vitality that suggests the streets of contemporary Paris. Degas contrasts their expressions – scornful, provocative, curious – and the awkward, tense poses of their immature bodies. Degas remained fond of this picture in his old age, and in many ways it anticipates later themes — the strained grace of the young dancers, the training of the body, the juxtaposition of different attitudes along a diagonal line. Yet this fresh, naturalistic rendering of a classical theme was attained after much experiment. The long evolution of the picture reveals in a fascinating way Degas's growing discontent with the cold abstractions and scholarly trappings of nineteenth-century history painting. The early drawings (Fig. 12) have a Raphaelesque grace, and there is an earlier version of the painting in Chicago which has classical accessories and is closer in feeling to the remote serenity of Puvis de Chavannes's vision of Antiquity. X-rays have shown that the figures in the London picture were originally more idealized, and the numerous changes in the girls' legs are clearly visible. The date of the repainting is, however, controversial. The picture was exhibited in the fifth Impressionist Exhibition of 1880, instead of the unfinished *Little Dancer of Fourteen Years*, Degas's most perfect treatment of the defiant ungainliness of adolescence.

Fig. 12 (right)
Young Spartan Girl

PENCIL, 22.9 × 36 CM. C.1860. PARIS, LOUVRE

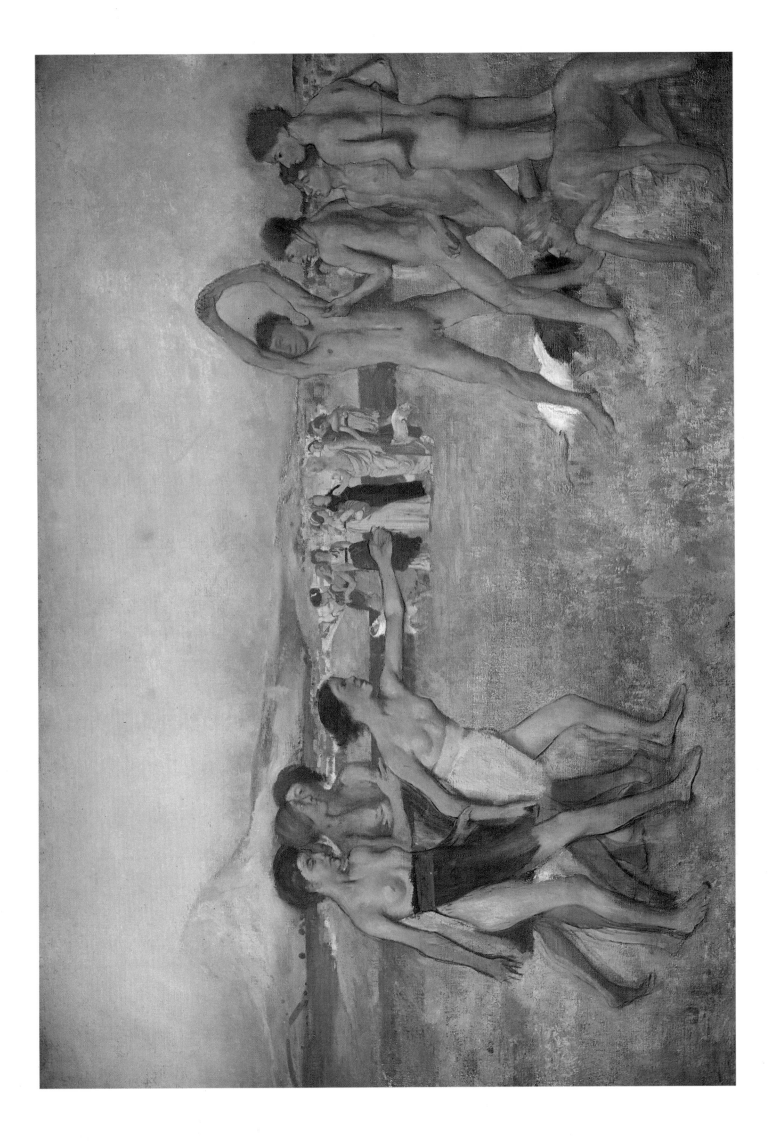

Semiramis Building Babylon

CANVAS, 85 × 258 CM. 1861. PARIS, LOUVRE (JEU DE PAUME)

This is one of a series of important compositions which reveal Degas's deep admiration for the great achievements of Renaissance and Romantic art. The exotic subject is characteristic of the Romantic era. Writers and painters were drawn to the barbaric splendour of the East and were fascinated by the monstrous sensual cruelty of Oriental rulers – Cleopatra, Sardanapalus, Semiramis. Semiramis, the legendary queen of Assyria and founder of Babylon, massacred her slaves after a night of love. As a young man Degas was interested in Romantic literature, and, characteristically, was here inspired by a Romantic treatment of this classical theme – a Meyer-Rossini opera first produced in 1860. The stillness of the composition suggests a theatrical production, and the figures look a little like an opera house chorus, rather uncomfortably squeezed in in front of the stage scenery. The

preparatory drawings (Figs. 13 and 14) are particularly beautiful, and both they and the frieze-like composition suggest the influence of Ingres and the Florentine Quattrocento; but the painting is an uneasy rendering of a Delacroix theme in an awkward mixture of styles. Theodore Reff's researches into the notebooks have revealed the astonishing range of copies that Degas made in preparation for the work. They show how widely Degas looked for material in exotic and European art, and how concerned he was to saturate his work with picturesque archaeological detail (as was Flaubert, for example, in *Salammbô*). Most obvious is the derivation of the horse from one in the Parthenon frieze. The stillness and passivity of the figures is in some ways closer to Moreau's *femmes fatales* than to the passion of the early Romantics.

Fig. 13 (left)
Study of Nude Figure

PENCIL 34.1 × 22.4 CM. C.1861. PARIS, LOUVRE

Fig. 14 (right)
Study of Kneeling Draped Figure

PENCIL, 30.1 × 24.2 CM. C.1861. PARIS, LOUVRE

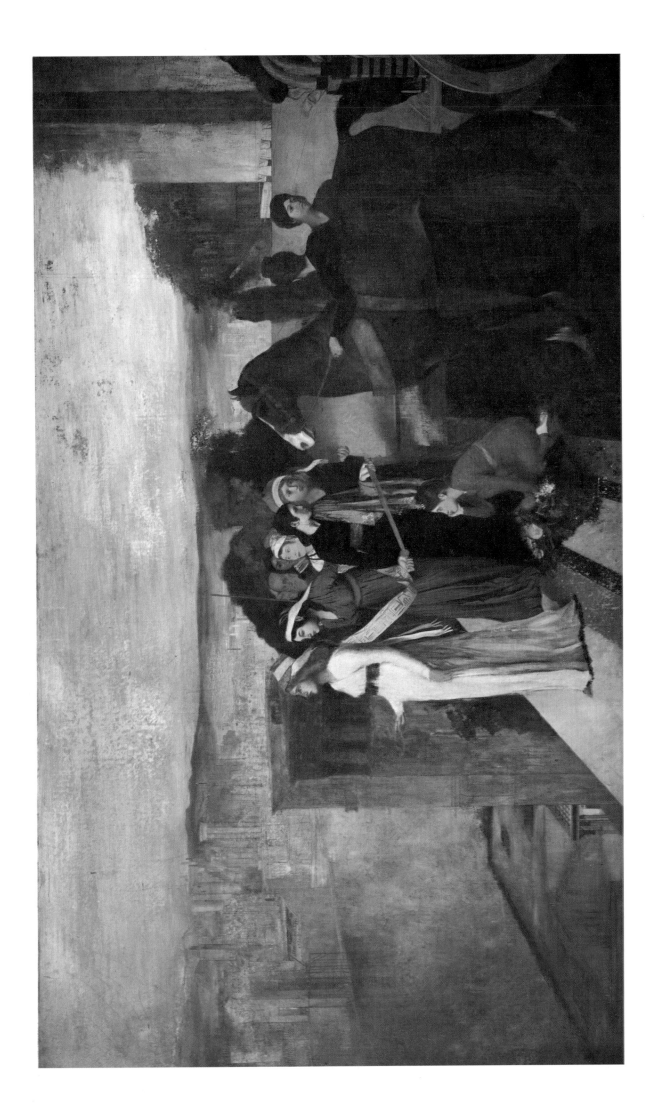

[library stamp]

Woman with Chrysanthemums

CANVAS, 74 × 92 CM. 1865. NEW YORK, METROPOLITAN MUSEUM (H.O. HAVEMEYER COLLECTION)

This strikingly original painting is dated 1865 over an earlier date, probably 1858; the portrait was almost certainly the last part to be painted. The exquisitely drawn lady, resting her head on her hand in a pose familiar from Ingres, is painted in calm browns, russet, and black. She seems lost in thought, aware neither of the spectator nor of the massive arrangement of stupefyingly colourful flowers against which she is squeezed. Most commentators note Delacroix's influence in the flowers. The precarious equilibrium between the cool lady and the riot of colour that she ignores is so haunting that it is tempting to speculate about its psychological roots. But it is safer to note that at this stage of his career Degas had absorbed the work of the two great masters of the previous generation, and that he was ready to use the most unconventional composition in the pursuit of a modern, informal style of portrait.

MERTHYR TYDFIL
TECHNICAL COLLEGE
LIBRARY

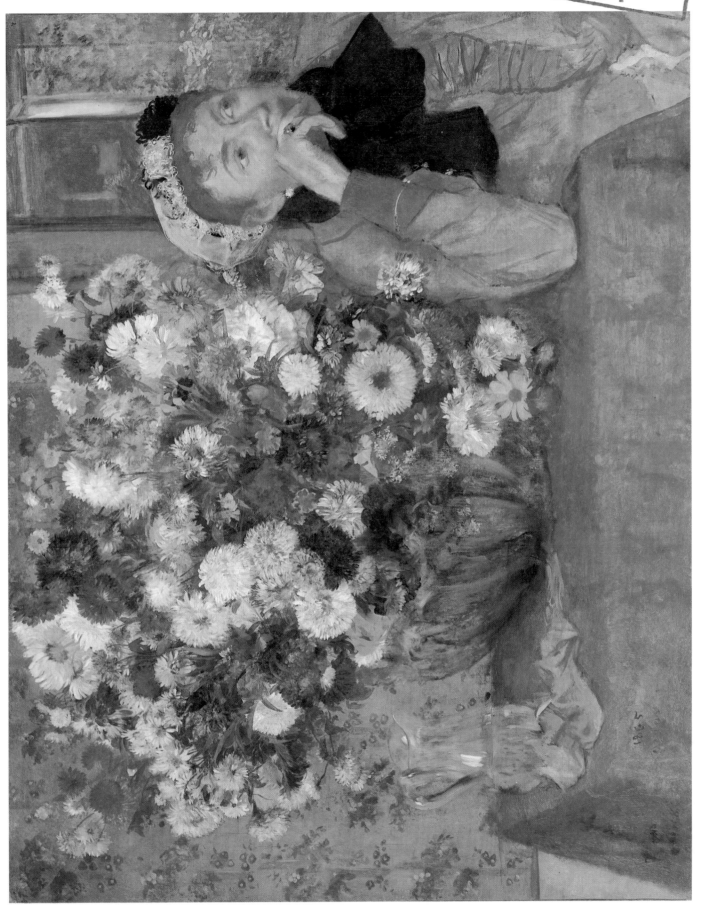

Duke and Duchess of Morbilli

CANVAS, 117.1 × 89.9 CM. C.1865. WASHINGTON, NATIONAL GALLERY OF ART (CHESTER DALE COLLECTION)

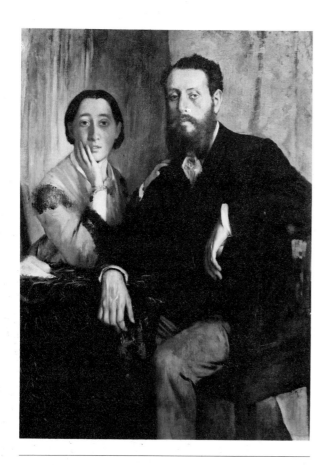

Degas's sister, Thérèse De Gas, married her first cousin, Edmondo Morbilli, in 1863, and this portrait was done shortly after their marriage. It remained unfinished; Degas seems to have been dissatisfied with the painting of the skirt, and scraped away a large area. The sitters are no longer formally posed against the neutral backgrounds of academic portraiture but are shown in their own sitting-room. The door is open; the Duke sits for a moment on the back of the sofa; the effect is vivid and immediate, and we feel that he and his wife have turned from their conversation to look out at the spectator. The emphasis on the decorative wall-paper leads on to much later works by Degas, and ultimately to Vuillard; bands of brilliantly coloured wall-paper serve as a background to several of Degas's late nudes. A slightly later painting of the same couple (Fig. 15) draws the two figures more closely together, both formally and psychologically. It is a complex portrayal of marriage, suggesting the almost arrogant strength of the man, and the tenderness and trust of the woman.

Fig. 15
Duke and Duchess of Morbilli

CANVAS, 116 × 89 CM. 1867. BOSTON, MUSEUM OF FINE ARTS

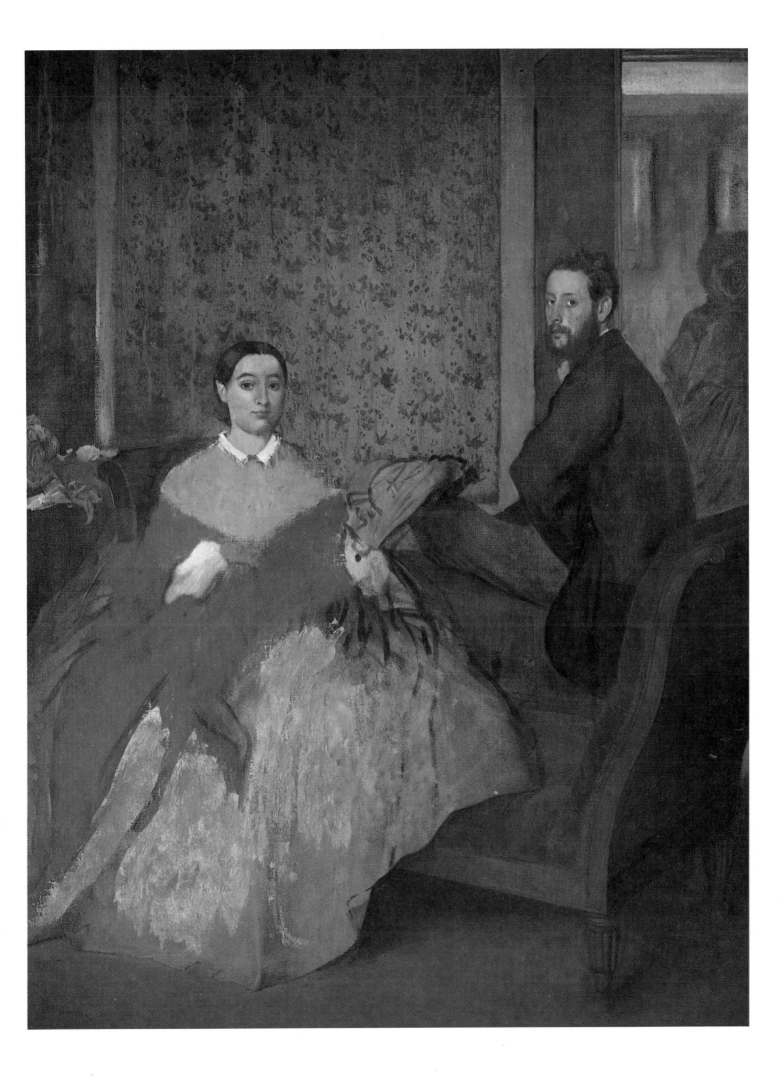

Portrait of James Tissot

CANVAS, 151 × 112 CM. 1868. NEW YORK, METROPOLITAN MUSEUM

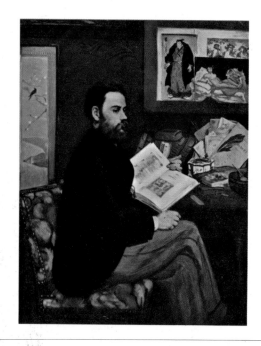

Fig. 16
EDOUARD MANET
Portrait of Emile Zola

CANVAS, 146 × 114 CM. 1867–8. PARIS, LOUVRE (JEU DE PAUME)

The painter James Tissot had met Degas in the studio of Lamothe, and throughout the 1860s they were close friends. In 1871 Tissot moved to England, where he won success with glossy paintings of fashionable Victorian life. After 1875 their friendship petered out. In Degas's portrait the careless elegance of the pose and the Romantic melancholy of the expression suggest the worldly sophistication of the society painter. The pictures in the room – overlapping and cut off by the frame to create a deliberately casual effect – are in fact carefully chosen to illustrate artistic styles, that, in different ways, attracted both Degas and Tissot. There are references to the German Renaissance, to the art of Japan, and to the theme of the *Déjuner sur l'herbe* – Tissot had himself painted an unexpectedly fresh *Déjeuner sur l'herbe* in the mid-1860s. Manet's *Portrait of Zola* (Fig. 16) shows a similar use of works of art to refer to the modern artist's interest in both the art of the East and Western naturalism. The *Topers* of Velázquez is glimpsed behind his own *Olympia*. Yet, beside the vitality of the Degas, the portrait is a somewhat stilted work; Zola is formally posed amongst a carefully patterned arrangement of attributes.

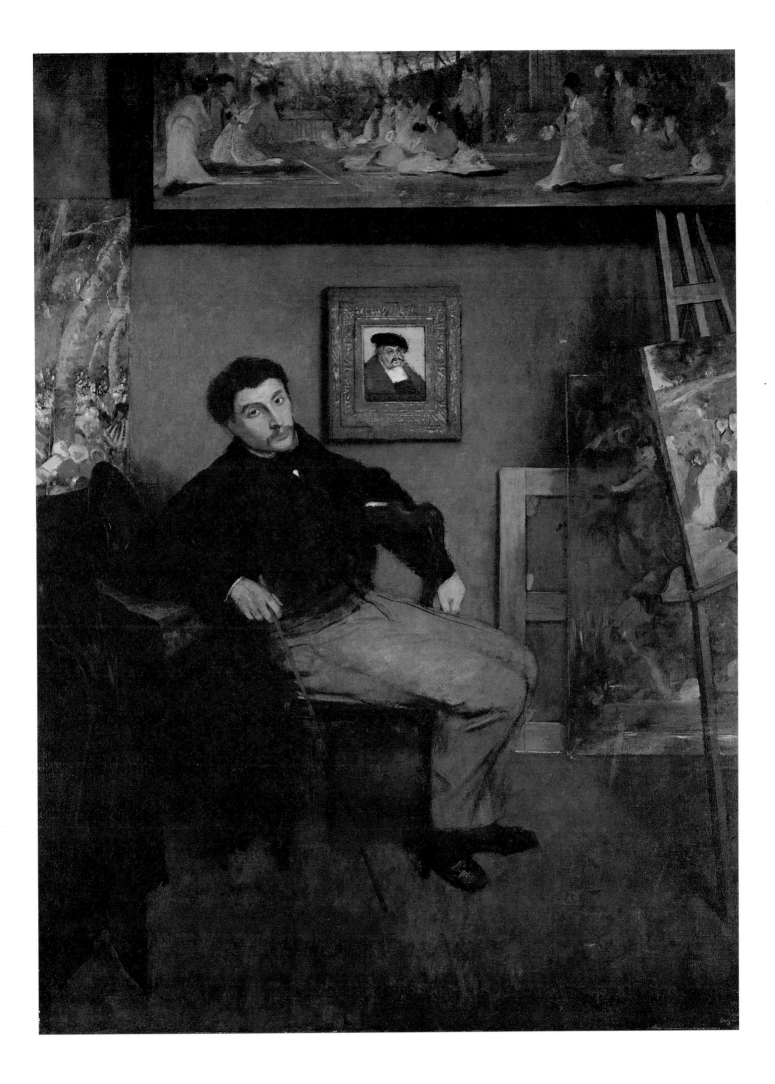

Interior

CANVAS, 81.3 × 114.4 CM. 1868–9. PHILADELPHIA, HENRY P.MCILHENNY

This disturbing work is a powerful study of inner conflict and sexual hostility. The figures, each darkly brooding, are thrust to the sides and separated by the prominent and somewhat mysterious objects in the room. Yet the steep perspective seems to pull them forcibly together, and suggests that they are trapped within an oppressively confined space. The tense, heavy atmosphere is further stressed by the strange glow of the lamp and the fire, which highlights the sensual beauty of the woman's shoulder and throws up an ominous shadow behind the man. Degas was particularly fond of this picture: he referred to it as 'my genre painting' and refused to explain the subject. Several attempts have been made to find a precise source: most convincing is Reff's suggestion that it was inspired by Zola's *Thérèse Raquin* and shows the wedding night of Thérèse and her lover. The couple have previously murdered Thérèse's first husband, and guilt has destroyed their passion.

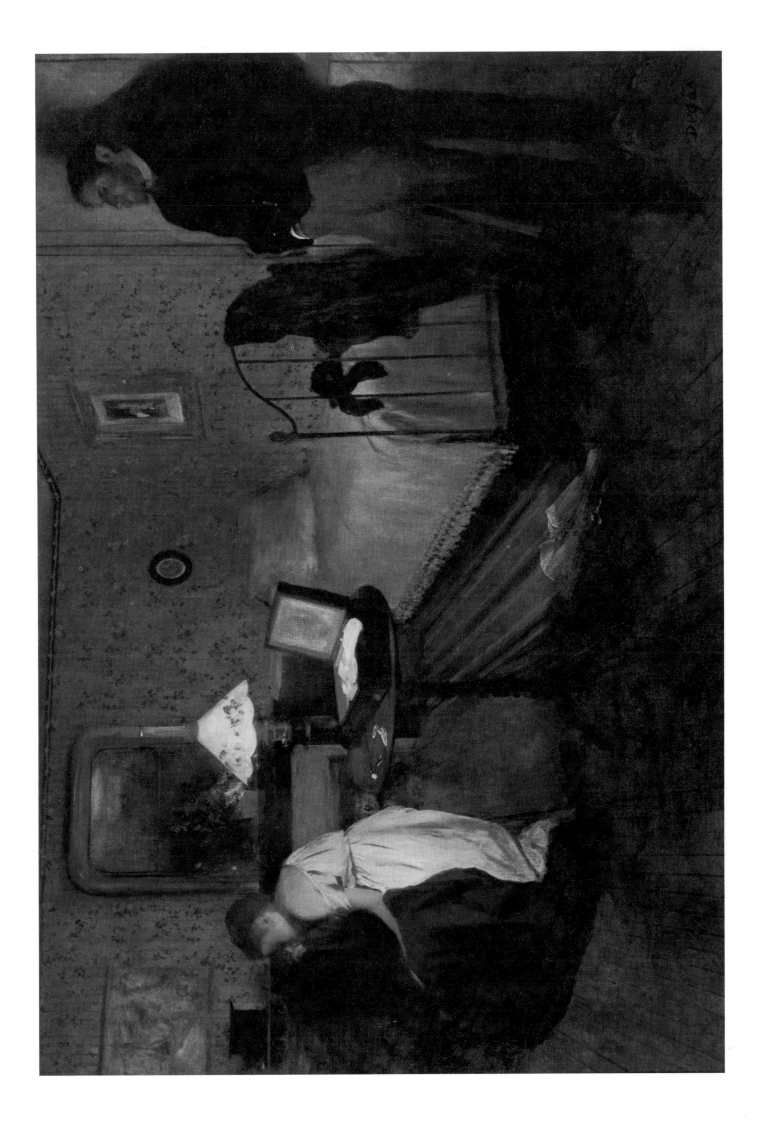

Race Course Scene, with Jockeys in front of the Stands

CANVAS, 46 × 61 CM. 1868. PARIS, LOUVRE (JEU DE PAUME)

The race-track became a favourite theme from the mid-1860s onwards; Paul Valéry wrote that the elegance and precision of the thoroughbred satisfied Degas's search for 'purity ... in contemporary reality'. In this painting he has arranged the men and horses in subtly varied poses along a receding diagonal, and has contrasted their nervous tension with the bolting animal in the distance. The delicate play on movements that echo, balance, and check one another, and the decorative beauty of the clear outlines and shadows against the flat, pale ground is carefully contrived. From New Orleans Degas was to write, 'And then I love silhouettes so much ...' Degas's interest in the horse was stimulated as much by art as by nature; he copied frescos by Gozzoli, paintings by Géricault, and English sporting prints. Reff has pointed out that two figures in this painting derive from Meissonnier's *Napoleon III at the Battle of Solferino*, and indeed Valéry relates how Degas insisted on demonstrating to him the 'exactness of rendering' in a Meissonnier statuette.

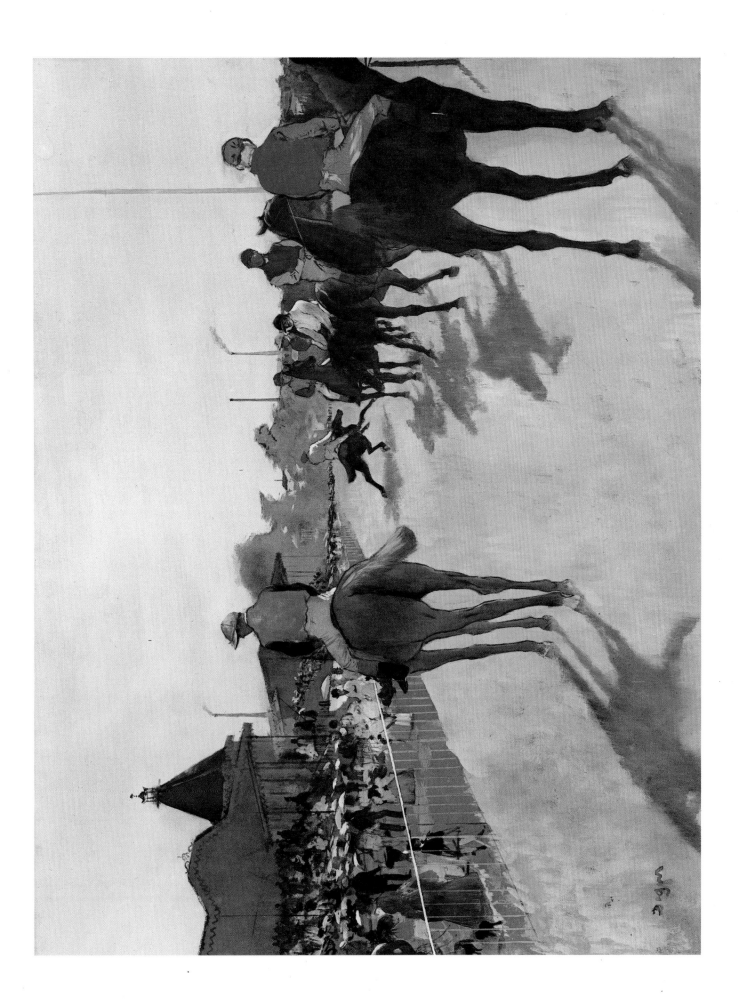

Madame Camus

CANVAS, 72.7 × 92.1 CM. C.1869–70. WASHINGTON, NATIONAL GALLERY OF ART (CHESTER DALE COLLECTION)

In the late 1860s Degas went regularly to Manet's salon and met many of his sitters there. Madame Camus was a doctor's wife who was interested in Japanese art. She was, like Madame Manet, a skilled pianist, and in a slightly earlier, more conventional work, Degas had shown her turning away from the piano. In this picture she is shown in the red glow of the fire, holding a Japanese fan and surrounded by all the comfort of a rich Second Empire drawing-room, suggested by a torchère with its head characteristically cropped by the picture-frame, the bottom edge of a gilt mirror, and the rich dappled colours of the chair and stool. The colours of these fabrics look forward to Vuillard, but the overwhelming impression of the painting is of a vast area of subtly differentiated red. Whistler's paintings dominated by a single colour are rather later, though in an earlier work, the *Music Room* (Fig. 17), he had experimented with the effect of artificial light in rich domestic interiors. While the colour of Degas's painting is unimaginable before the third quarter of the nineteenth century, the rococo line comes from Boucher and Fragonard; both of them, however, would have given the sitter more clearly defined features. Perhaps the final impression of this very beautiful painting is a sense of faint mystery, even ambiguity.

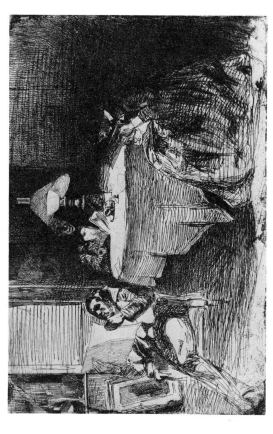

Fig. 17 (right)
JAMES MCNEILL WHISTLER
The Music Room

ETCHING, 14.5 × 21.7 CM. C.1859. PRIVATE COLLECTION

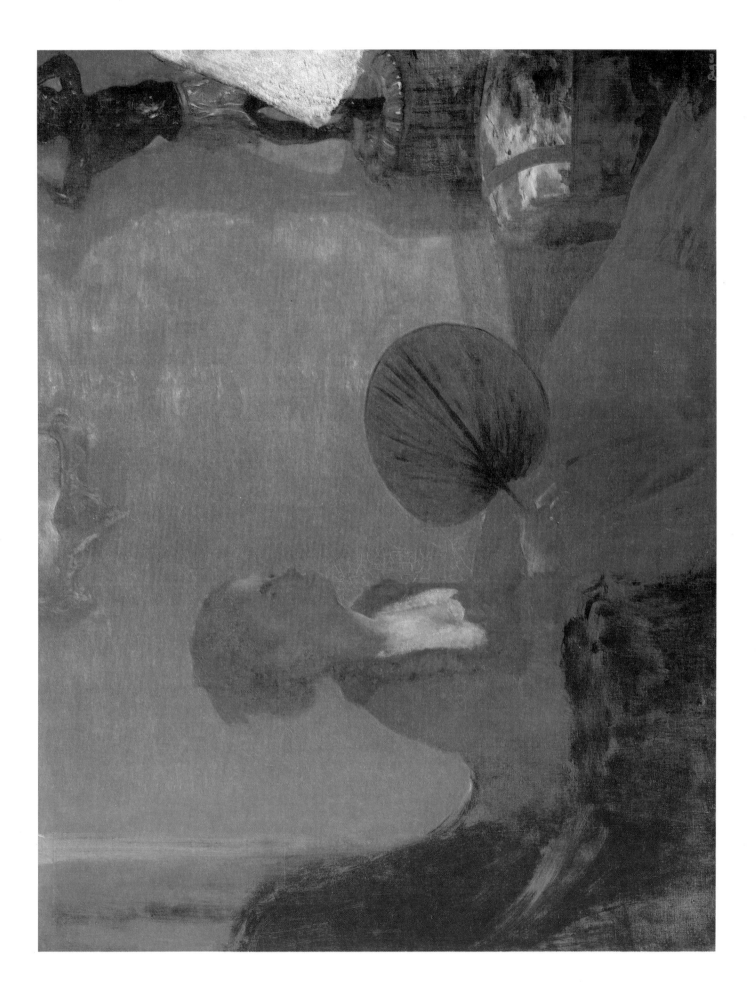

The Dance Foyer at the Opéra, Rue Le Peletier (detail)

CANVAS, 32.3 × 46 CM. 1872. PARIS, LOUVRE (JEU DE PAUME)

This work, and a closely related small panel in New York (Fig. 18), are the first of Degas's many paintings of the practice rooms at the Opéra; the picture shows the choreographer and ballet master, Louis François Mérante, instructing a young dancer. The picture was exhibited in London at the Fifth Exhibition of the Society of French Artists, where it scored a great popular success. At first glance the picture may give an impression of casual informality and there are certainly some touches of that sort, such as the tutu glimpsed through the door. But it is no accident that the weat er of the tutu echoes precisely the line of the main foreground figure; indeed the whole picture is calculated with a mathematical exactitude that seems to be symbolized by the crisp red line of the practice bar. The moment shown is the silent pause as the dancer takes up her position, when she stands as still as the prominent chair on which she has left her fan. As in some of Watteau's dance paintings, the main figures (the ballet master and the dancer in re-hearsal) are linked by a strong psychological bond, emphasizing the

feeling of a world of movement caught in a frozen moment. The effect of light and space are remarkable for so small a picture; the light falls from the right, catching the white sleeve of the ballet master and throwing a deep shadow across the face of the seated girl.

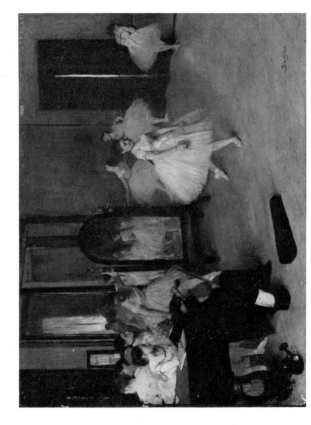

Fig. 18 (right)
The Dancing Class

OIL ON WOOD, 19 × 27 CM. 1872. NEW YORK, METROPOLITAN MUSEUM OF ART

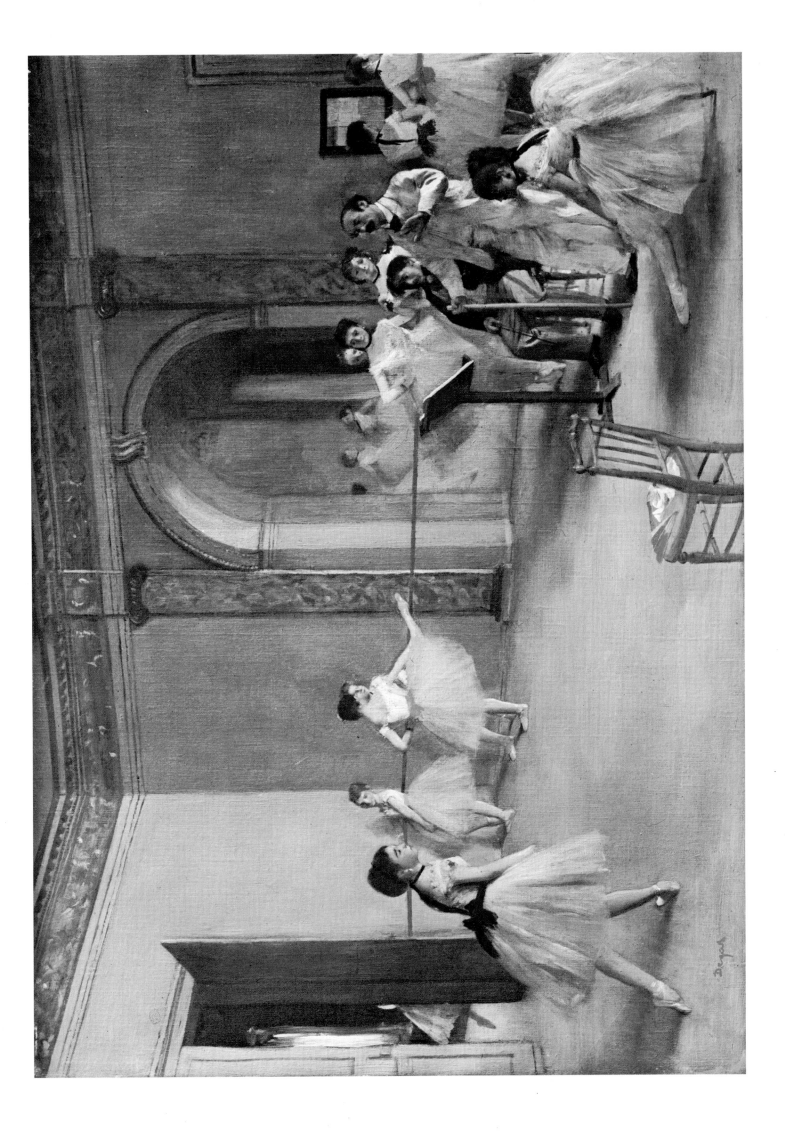

The Musicians in the Orchestra

CANVAS, 69 × 49 CM. C.1872. FRANKFURT, STÄDELSCHES KUNSTINSTITUT

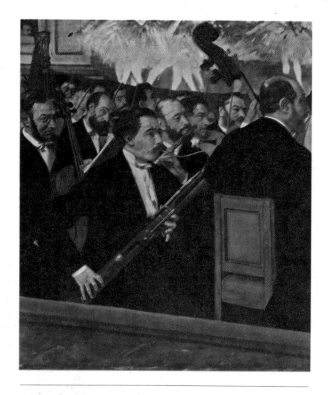

Between 1868 and 1876 Degas painted a series of group portraits against the background of a brightly lit stage. The first was the *Orchestra of the Opéra* (Fig. 19), which shows Degas's friend, the bassoonist Désiré Dihau, as the focus of a lively, elaborate arrangement of sharp diagonals and rectangles. The emphasis is on the musicians; each face is intensely individual and their professional skills sharply observed. The Frankfurt picture is more boldly structured. The vertical canvas is sharply divided into rectangles that emphasize the plane; this composition stresses the contrast between the dark foreground with the soberly dressed musicians, and the glamour and brilliant artificial light of the stage. The dancers are no longer abruptly cut off, as in the earlier picture, but compete for attention with the musicians. This increased interest in the dancer led to Degas's obsession with the excitement, the light, and the unexpected juxtapositions offered by the spectacle of the ballet.

Fig. 19
The Orchestra of the Opéra

CANVAS, 53 × 45 CM. 1868-9. PARIS, LOUVRE

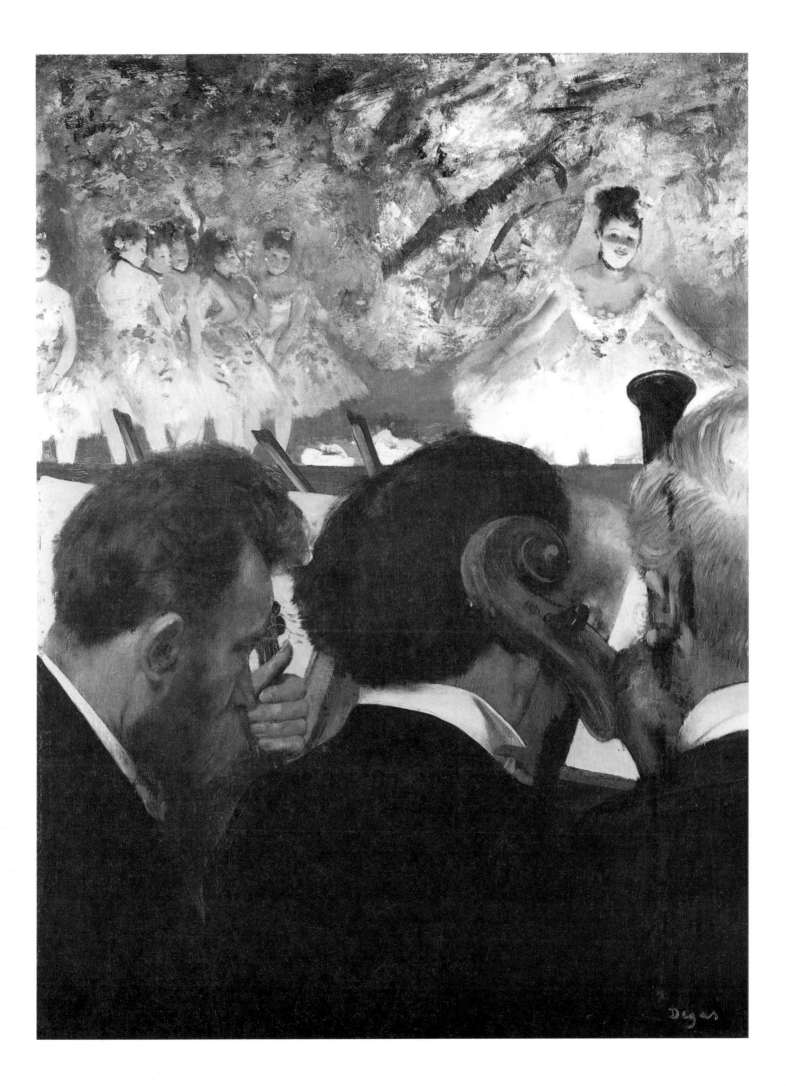

Portrait of Estelle Musson De Gas

CANVAS, 65 × 54 CM. 1872. PARIS, LOUVRE (JEU DE PAUME)

Degas painted three portraits of Estelle Musson, the wife of his brother René, while on a visit to New Orleans in 1872 3. Estelle was blind, and Degas, who so feared this condition, wrote compassionately to a friend, 'My poor Estelle, René's wife, is blind as you know. She bears it in an incomparable manner ...' In this portrait she is shown in a corner of her own drawing-room, and yet the work lacks the relaxed informality of the Morbilli portrait. The slim, pallid figure, uneasily caught between chair and wall, seems almost threatened by the glowing colour and fleshy, spidery leaves of the plant. In the tenderer Washington picture (Fig. 20), by contrast, her isolation is more poignant; her frailty seems cherished by the softness of the muslin and the delicate range of pale pinks and greys. It is a more overtly charming work, and Dr Boggs has suggested that Degas intended the fluency and beauty of the paint to rival that of Manet.

Fig. 20
Portrait of Estelle Musson De Gas

CANVAS, 73 × 92 CM. 1872–3. WASHINGTON D.C., NATIONAL GALLERY OF ART

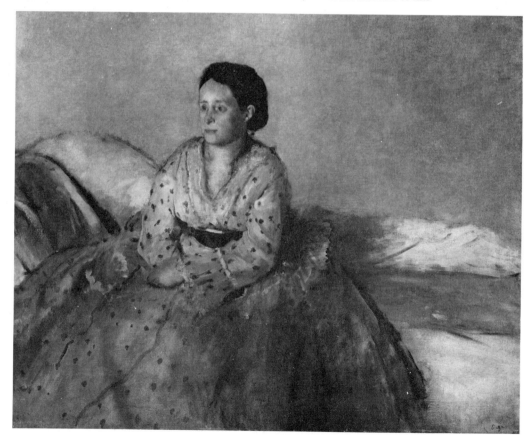

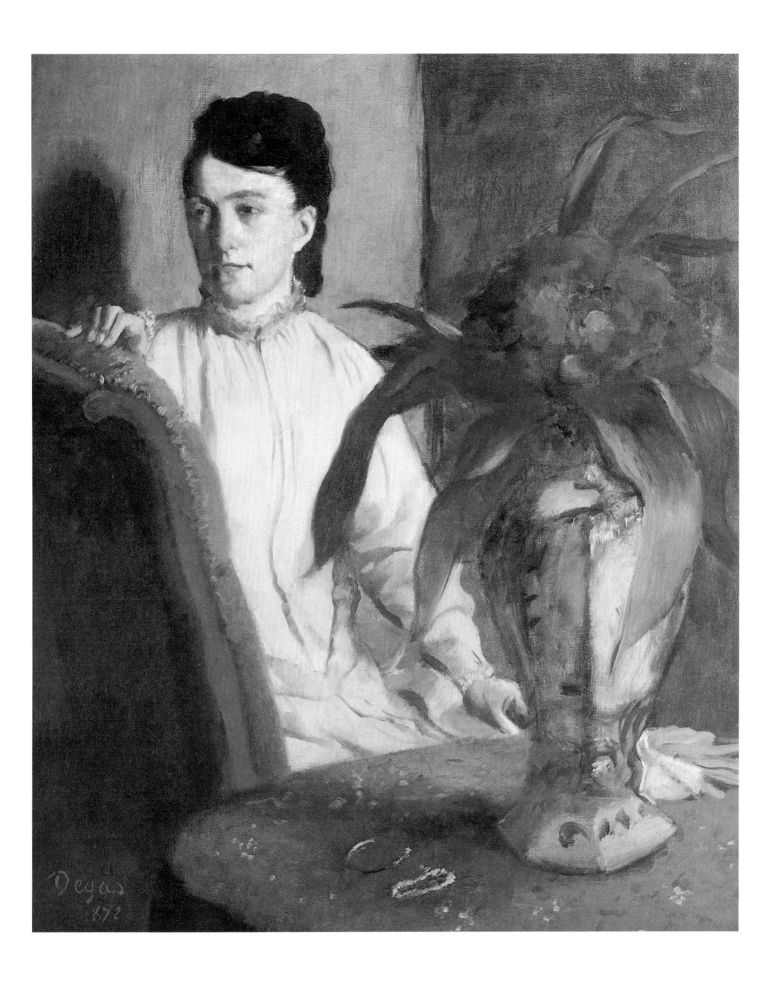

The Cotton Market

CANVAS, 74.5 × 91.25 CM. 1873. PAU, MUNICIPAL MUSEUM

This picture was painted in New Orleans, where Degas visited his brothers in 1872–3. It is both a scene of everyday life, showing the buying and selling of cotton, and a group portrait of several of his relatives who were in the cotton business. It is an elaborate work, utterly convincing in its air of almost photographic reality, and it marks the climax of one phase of Degas's development. The artist is here the detached *voyeur*; the viewpoint – through an open window – distances the spectator from the busy activity of the office. As in the later '*A la Bourse*' (Fig. 6), Degas here shows men totally involved in their professional activities, unaware of any spectator. Each figure is acutely observed: there is a sharp contrast between the precision with which Michel Musson (Degas's uncle) examines a sample of cotton in the foreground and the more nonchalant poses of the artist's brothers, who were visitors to the office. René reads a newspaper and Achille lounges against a window-sill in the background. The apparently casual arrangement of figures is held together by the rapid perspective, and by the crisp rectangles of the windows, shelves, and books. The fall of light, emphasizing the unexpected beauty of the white of the cotton and the shirt-cuffs against the black of the men's suits, is observed with a delicacy reminiscent of Dutch genre. Degas intended the picture for an English market; in 1873 he wrote to Tissot, 'I have attached myself to a fairly vigorous picture which is destined for Agnew and which he should place in Manchester: For if a spinner ever wished to find his painter, he really ought to hit on me... A raw picture if ever there was one, and I think from a better hand than many another... I am preparing another less complicated and more spontaneous, better art, where the people are all in summer dresses, white walls, a sea of cotton on the tables.'

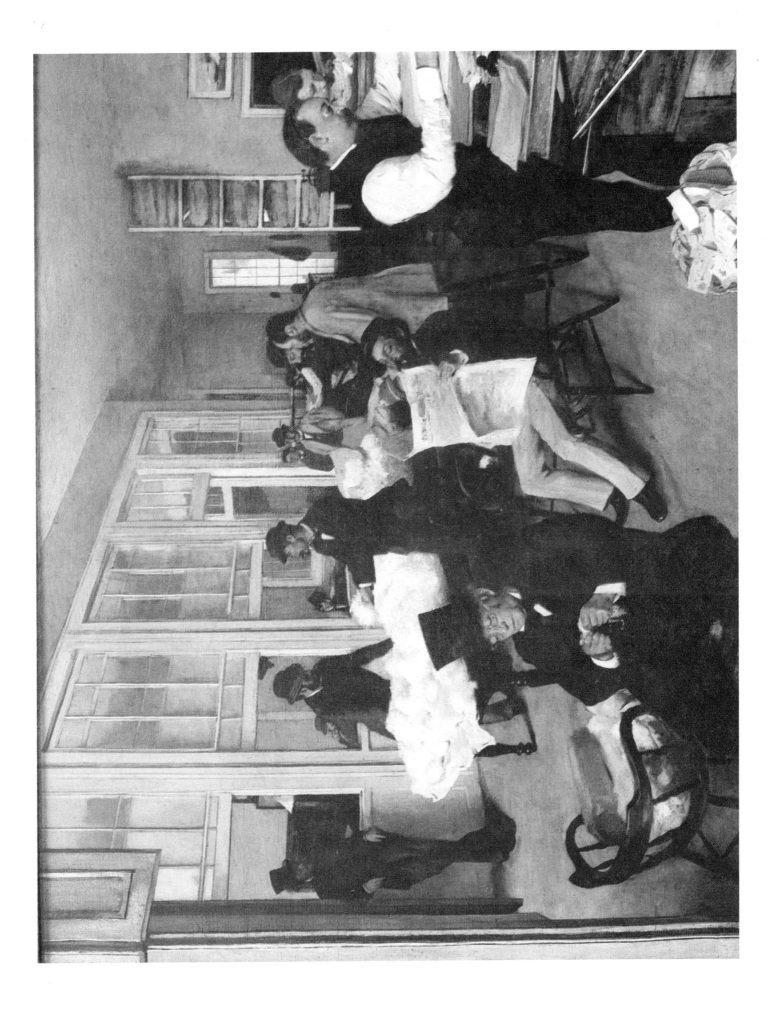

Horses on the Course at Longchamp

CANVAS, 30 × 40 CM. C.1873–5. BOSTON, MUSEUM OF FINE ARTS

As in most of Degas's race-track scenes, this charming little picture shows not the race itself but the scene a few moments before the start, as the horses are warming up. The effect of spontaneous informality is, in fact, calculated with Degas's usual care. The smudgy background – the hills of Boulogne under a watery sky – accentuate the sharp focus of the foreground, where a frieze of horses is thrown up with hard-edged clarity against a green as pale as in any of Degas's pastels. The horses themselves, mostly seen from behind, may seem at first sight to have been caught as casually as in a snapshot, but their nervous silhouettes are distributed with the utmost finesse, and their dark shapes contrast in turn with the gay patches of colour of the jockeys' racing silks. In the later 1860s Degas made very many drawings of jockeys on horseback, and drew on this collection of poses for the racing scenes painted between 1868 and 1872, all of which were carefully planned in the studio.

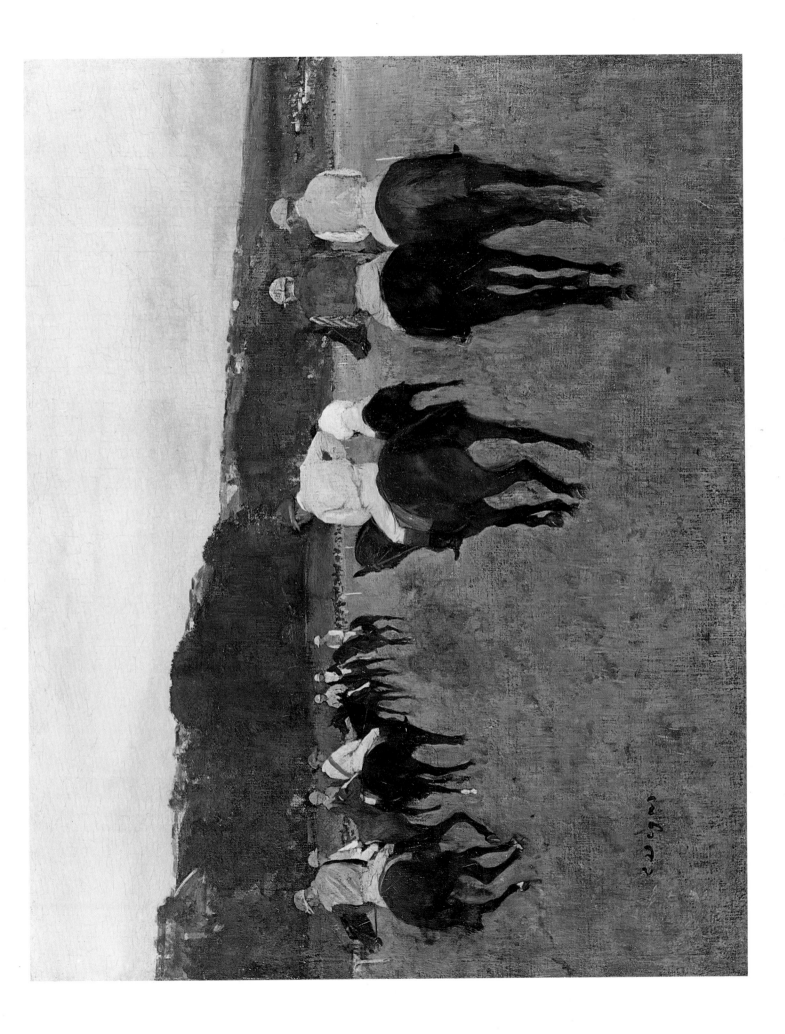

The Rehearsal

CANVAS, 59 × 83.75 CM. 1873–4. THE BURRELL COLLECTION – GLASGOW MUSEUMS & ART GALLERIES

This charming picture is one of Degas's many paintings of the Rehearsal Rooms. Preparatory drawings show with what care Degas studied the rôle of each figure, and yet their arrangement, in apparently unconnected groups, seems brilliantly to capture a trivial moment. The painting lacks the emphasis on the relationship between the ballet master and dancer that creates the focus in *The Dance Foyer at the Opéra* and *The Dancing Class* (Plates 11 and 19). Here, the composition is cut by the frame on both sides; we catch only an intriguing glimpse of the ballet dancer's legs as she descends the staircase; the foreground group, their backs turned to the dancers, are pushed to one side. The groups of figures are related with great subtlety to the empty space in the centre; it is this sharp division, and the deep diagonals of the clearly defined floorboards, set off against the verticals of the windows, that give the composition a sense of taut precision. The painting retains some of the tender feeling of the *Foyer* (Plate 11), but Degas's treatment of light and colour, and his rendering of the texture of materials, has become softer, brighter, and more painterly; the sashes of the girls are larger and more vividly coloured. The room is seen *contre-jour*, and Degas explores with delicacy the light that captures the shoulders and arms of the foreground figures, softly veiling their faces, and creating patterns of shadow across the floor. Keith Roberts first pointed out that the picture was described by Edmond de Goncourt, who visited Degas's studio in 1874: 'It is the foyer of the dancing school where, against the light of a window, fantastically silhouetted dancers' legs are coming down a little staircase, with the brilliant spot of red in a tartan in the midst of all those white, ballooning clouds…And right before us, seized upon the spot, is the graceful twisting of movements and gestures of the little monkey-girls.'

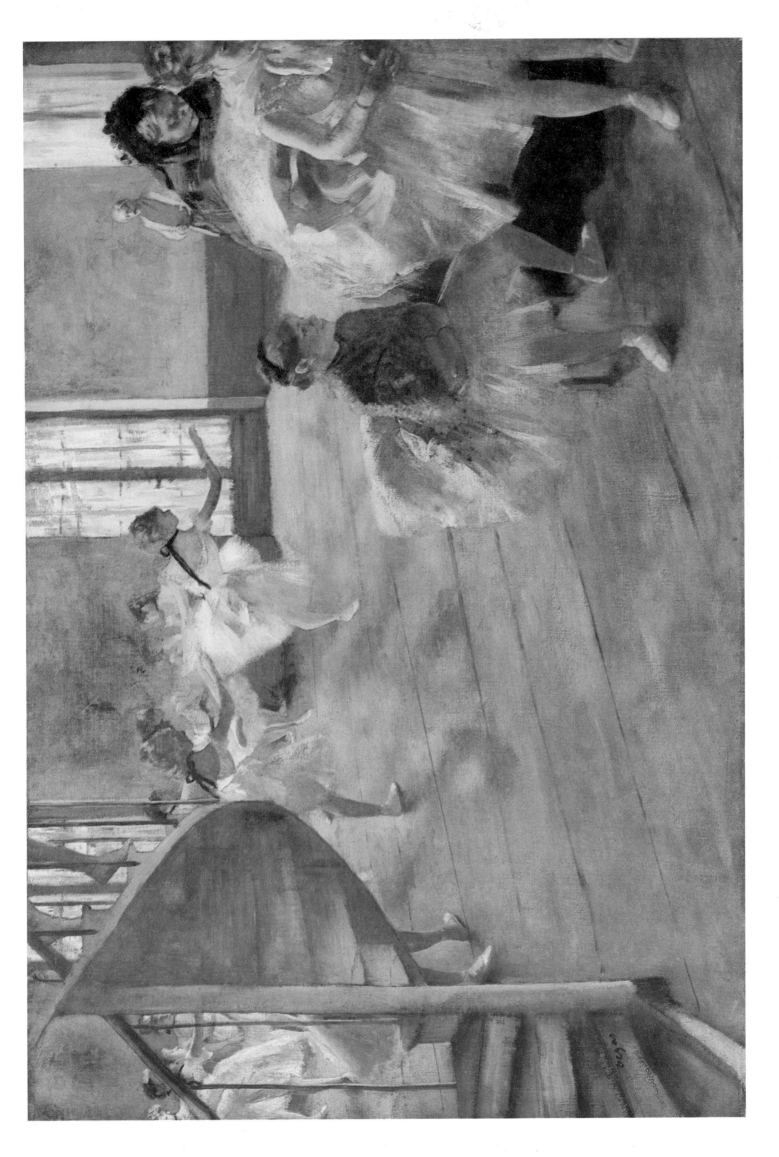

The Ballet Rehearsal

CANVAS, 65 × 81 CM. C.1873–4. PARIS, LOUVRE (JEU DE PAUME)

This is one of three paintings that Degas did between 1873 and 1874 showing a rehearsal taking place on stage. It retains little of the quiet charm of the paintings of 1872; the movement is livelier, the figures crowded together, and Degas is attracted by the unexpected poses of dancers seen from above and cut into by the decorative shapes of the stage flats. He creates a sharp contrast between the inelegant and awkward poses of the figures on the left – yawning, stretching, tying their shoes – and those who strive for professional grace on the right. The painting wittily emphasizes the everyday reality that lies behind the glamour of the ballet. It is a variant of a picture in the Metropolitan Museum (Fig. 21), and Degas repeats some of the figures. It is, however, a simpler work, lacking the sharp wit of the contrast between the vigorous action of the black-suited instructor, the bored director, and the frothy dresses of the girls; the startling scrolls of the double-bass have also vanished.

Fig. 21

The Rehearsal of the Ballet on the Stage

OIL COLOURS WITH TURPENTINE, WATERCOLOUR AND PASTEL OVER PEN AND INK DRAWING ON PAPER MOUNTED ON CANVAS, 53 × 72 CM. 1873–4. NEW YORK, METROPOLITAN MUSEUM OF ART

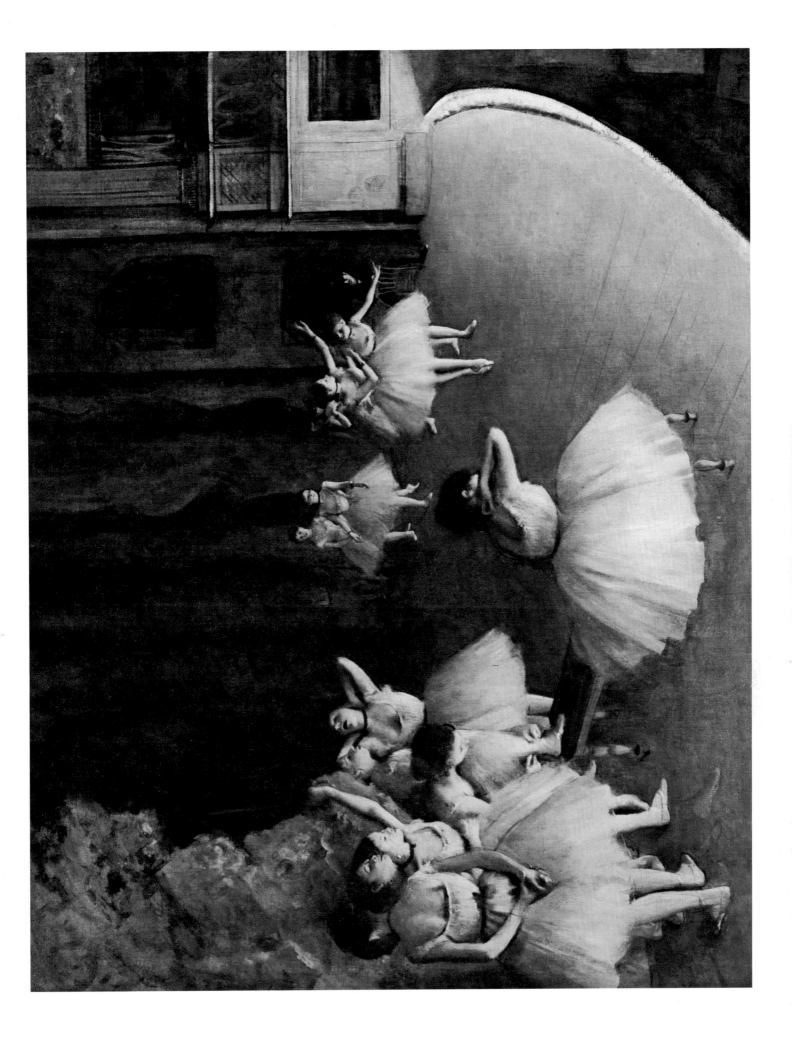

Two Dancers on the Stage

CANVAS, 62 × 46 CM. 1874. LONDON, COURTAULD INSTITUTE GALLERIES

These two figures are worked up from the group at the right of the Louvre *Ballet Rehearsal* (Plate 17). In this version the space between the figures is widened out and the viewpoint is lowered, both of these changes helping to make the dancer on her points appear lighter and more glamorous. The strong diagonal of the scenery and figures, the bare boards that make up half of the picture, the figure arbitrarily cut off by the picture-frame, and the glimpse into the wings behind the scenery flats are all devices that frequently recur in Degas's ballet pictures. In this little painting what impresses us most is the close-up effect and the startlingly great empty space of the stage into which the dancers are about to move.

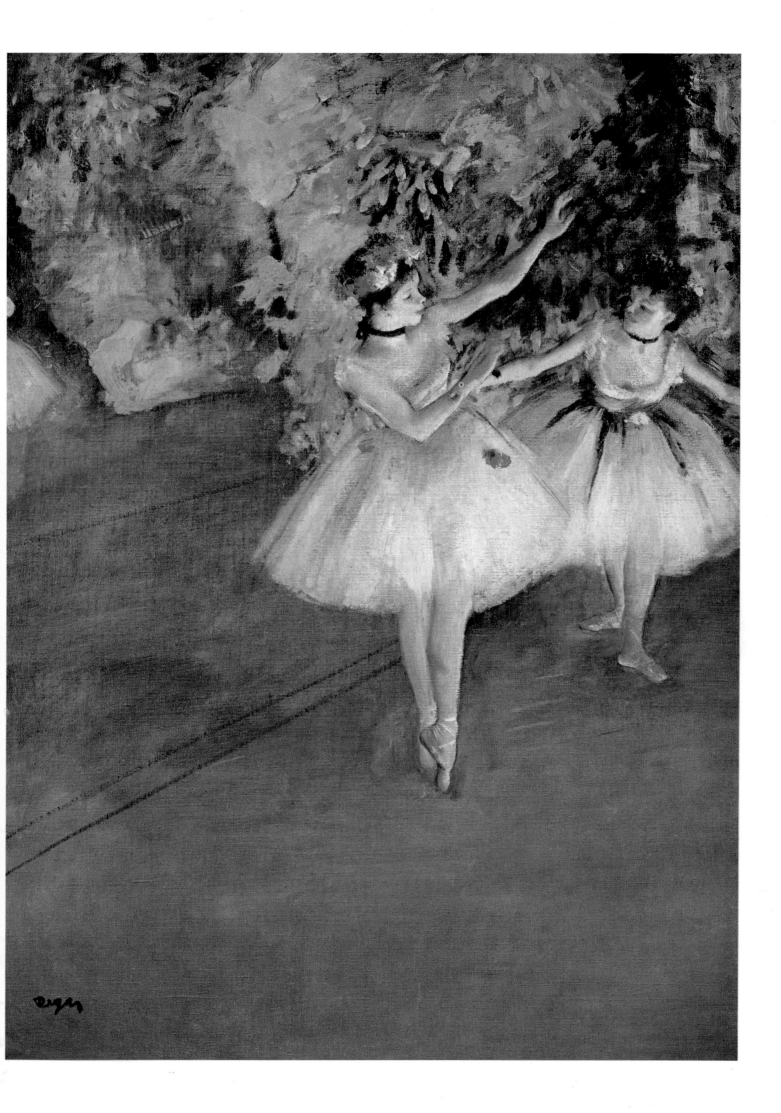

The Dancing Class

CANVAS, 85 × 75 CM. 1874. PARIS, LOUVRE (JEU DE PAUME)

This scene was painted about two years later than Degas's first dancing class, *The Dance Foyer at the Opéra* (Plate 11), and it is a very different kind of picture. Like the *Foyer* it is held together by a strong composition: the viewpoint is high, and the eye is swiftly drawn to the corner of the room by the steep perspective and the rapidly diminishing figures of the dancers; the verticals of the pilasters and the dancing master's stick are particularly evident. But within this firm framework the scene is one of frothing gaiety, chattering activity, colour, and movement. The earlier picture, despite its charm, has an element of solemnity. In this work Degas catches the unexpected and often ugly gesture and expression. The girls yawn, scratch, adjust their dresses; a small dog waits patiently; in the background some mothers tend their daughters (a motive developed in later works, Degas particularly liking the contrast of dress and attitude). In all, the work is much more a piece of observation of life backstage, full of sharply observed and witty detail. The watering-can in the corner was used for laying the dust and Degas incorporated it into other pictures. Here it mimics the pose of the standing dancer in the foreground. The ballet master is the once celebrated dancer Jules Perrot; the weight and mature distinction of his pose contrasts with the unformed grace of the young dancers. The pose particularly pleased Degas and he used the same figure in other works (Fig. 22).

Fig. 22.
The Dancer, Jules Perrot

OIL COLOURS WITH TURPENTINE ON PAPER, 48 × 30 CM. 1875.
PHILADELPHIA, HENRY P. MCILHENNY

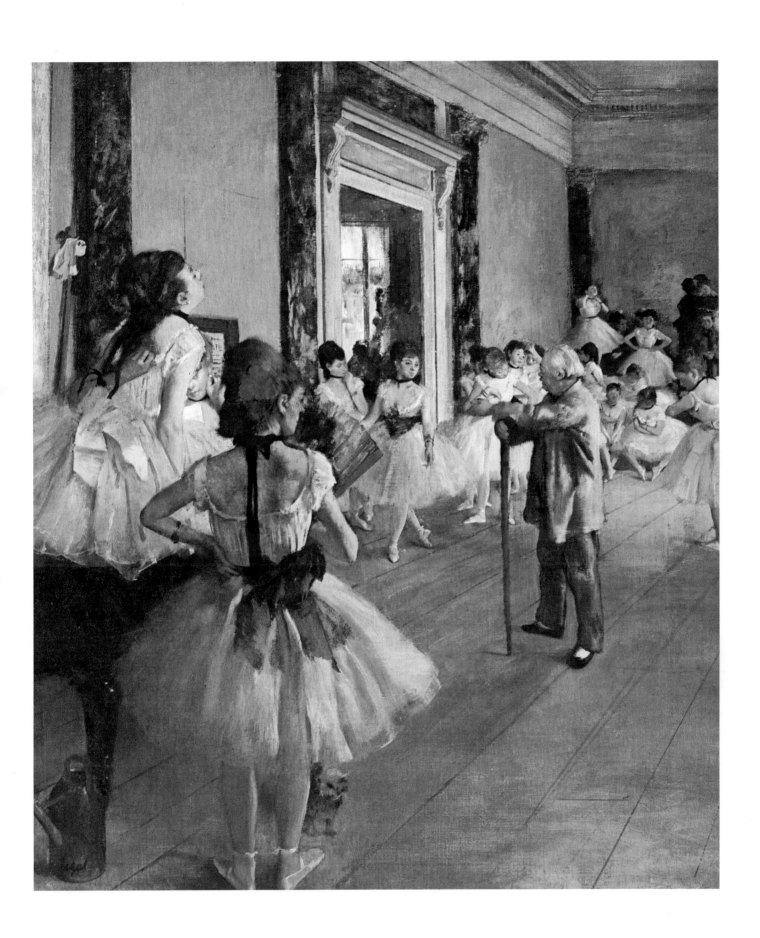

Dancer Posing for a Photographer

CANVAS, 65 × 50 CM. 1874. MOSCOW, PUSHKIN MUSEUM

This is one of a group of works from the early 1870s in which Degas seems to have been attracted by the *contre-jour* effects of a figure posed before a window. It is a daring composition, in which the undisguised horizontals in the foreground, and the verticals in the upper half of the picture, reduce the space to flat bands parallel to the plane. The sharp horizontal division may be compared to the division in *The Musicians in the Orchestra* (Plate 11), and the breaking up of the surface into geometric shapes is paralleled in some of Whistler's small oils. Equally remarkable is the distortion of the figure drawing, which seems at first glance to anticipate Matisse. In fact the legs are drawn in precisely the perspective – accurate but unnatural – that would be produced by a camera too close to its subject. The drawing of the legs makes the figure look awkward, and there is something both touching and amusing in this piquant girl, her face so full of character, her hair so carefully dressed, straining to retain a pose for the photographer. Degas was constantly aware of both the glamour and the vulnerability of young dancers, and in one of his poems wrote: 'The violins squeak. Fresh from the blue water, Silvana rises, curious and gambolling, the happiness of rebirth and pure love plays on her eyes, her breasts and all her new being. But a trifle puts to flight the mysterious beauty. Leaping, she bends her legs too far: like the leap of a frog in the ponds of Cytherea.' (Quoted by Phoebe Pool, *Degas*.)

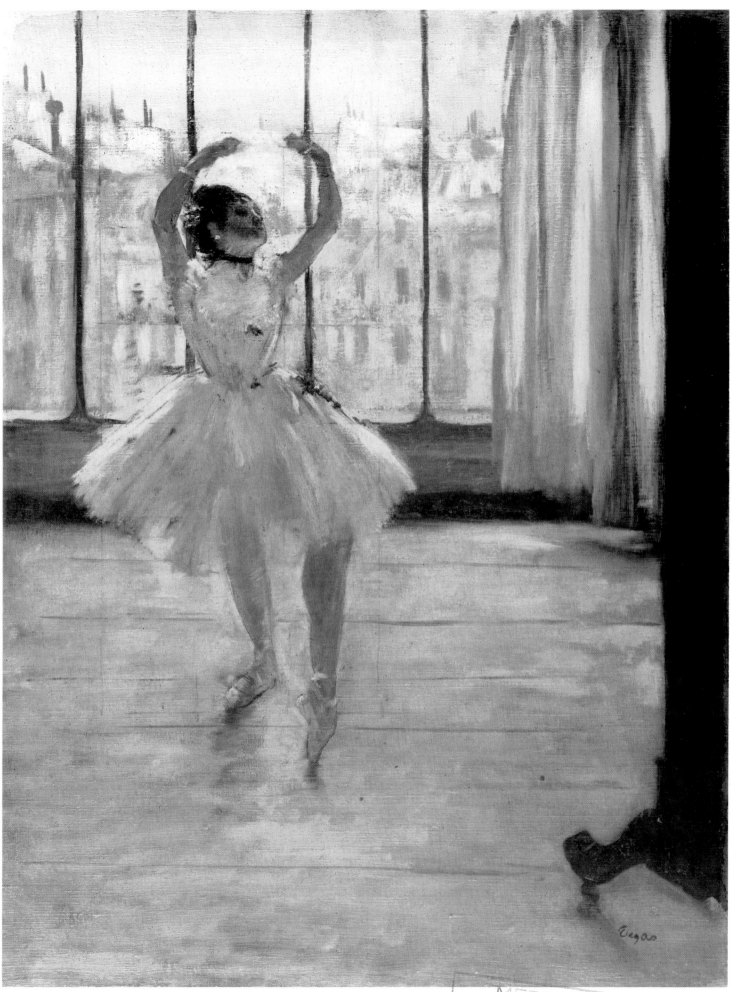

MERTHYR TYDFIL
TECHNICAL COLLEGE
LIBRARY

Girls Combing their Hair

PAPER, 34.5 × 47 CM. 1875-6. WASHINGTON, THE PHILLIPS COLLECTION

The motive of combing the hair is much commoner in interior scenes than in *plein-air* paintings, and taking only the subject-matter into account the obvious comparison for this small oil is the National Gallery *Beach Scene* (Plate 23) which Degas painted a year or so later. But any similarity is superficial. The National Gallery painting, with its marvellously interrelated central group and ironically observed little vignettes of life at a fashionable resort, does create a genuine impression of *plein-air* at the seaside, and firmly fixes a particular social milieu. This painting, despite the sketchy backdrop of trees and river, is clearly a much more academic exercise. The same model is used for the three different poses and the figures are spread out in a flat frieze. The painting is no more than half finished, but the effect for which Degas was working seems to be much closer to the Cleveland *Frieze of Dancers* of c.1893 (Fig. 37) than to any of Degas's paintings of the 1870s. There is certainly no interest in the model as anything more than a subject for a design; the figures in the painting are arranged to contrast with each other in much the same way as the horses in the racing scenes.

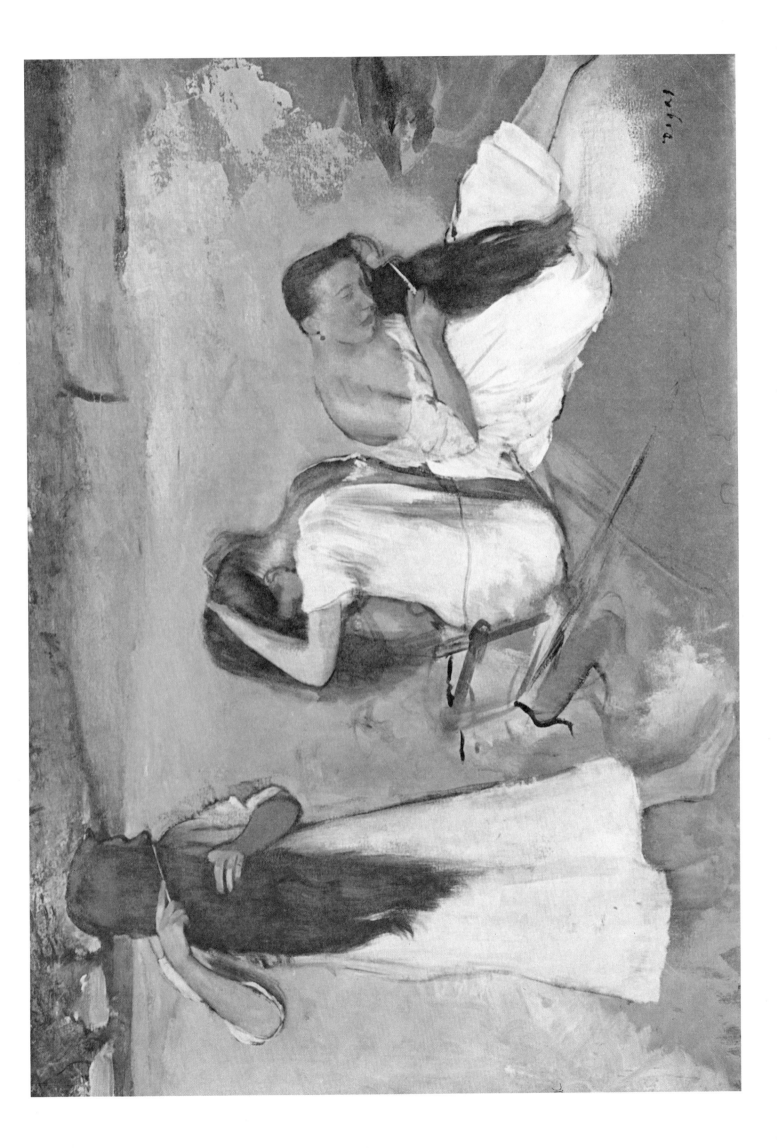

'L'Absinthe'

CANVAS, 92 × 68 CM. 1876. PARIS, LOUVRE (JEU DE PAUME)

This painting shows two of Degas's friends – Marcellin Desboutin, an artist, and Ellen Andrée, an actress – at a table in the Café de la Nouvelle Athènes. The café became popular with artists and writers of the Naturalist movement in the mid-1870s. The painting is, however, more genre than portrait. It is one of Degas's most brilliant illustrations of Parisian life, and seems to capture perfectly the slow and somewhat listless mood of the café. The two figures – both absorbed in their own thoughts, the woman somewhat forlorn and unhappy – linger over a drink and watch the world go by. The composition is carefully organized to create the sense of a corner of life, suddenly glimpsed. The figures are thrust to one side, caught between the sharp and lively diagonals of the table-tops and their own reflections in the glass behind. In his notebook Degas made a pencil-sketch of the café, on which he jotted down very precise observations on colour. As Theodore Reff has stressed, Degas was interested, as were the Naturalist writers, in an authentic description of a particular environment, and it has often been noted that the mood of the picture recalls Zola's *L'Assommoir* (*The Dram Shop*). The cold colours and air of detachment contrast sharply with the gaiety of the paintings of café life by Renoir and Manet.

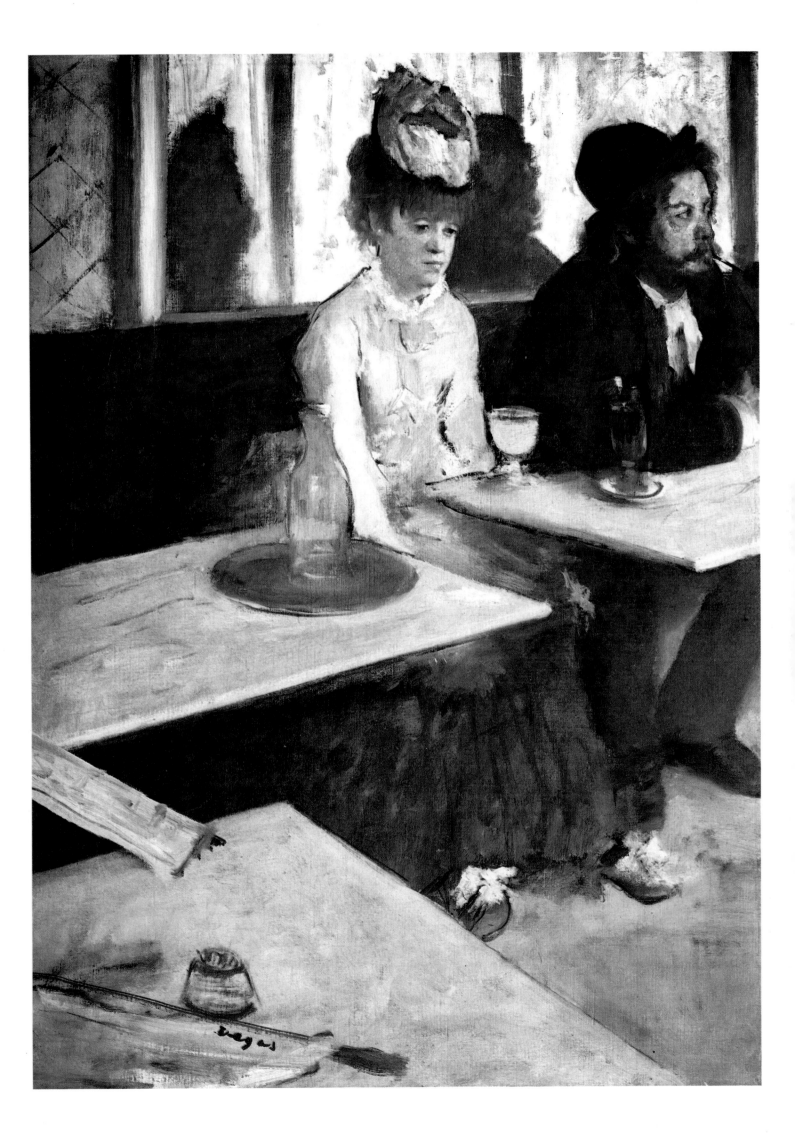

Beach Scene

PAPER MOUNTED ON CANVAS, 47 × 82.5 CM. 1876–7. LONDON, NATIONAL GALLERY

The seaside was a favourite Impressionist subject, and this painting is perhaps Degas's most spontaneous rendering of a carefree, sunlit day. The composition has a deliberately random air – objects are amusingly scattered about, the lively groups of figures are unconnected, and there are abrupt contrasts of scale. Yet Degas stressed that the painting was done in the studio, and the two figures in the centre dominate the composition. Degas was interested in the contrast between the awkward, yet relaxed pose of the young girl, who carelessly toys with the edge of the parasol, and the solid body and slow, precise gestures of the nurse. (In the 1880s Degas was to return to the theme of women having their hair combed by maids.) In 1869 Degas had visited Boulogne with Manet, and this work has something of the freshness of Manet's beach scenes. During their stay Degas had made many sketches of the seashore (Fig. 23), and their delicate poetry recalls the Whistler studies of 1865. In 1873 Degas saw the studies in London, and wrote in admiration of their 'mysterious mingling of land and water'.

Fig. 23
Seascape with Ships in Sail

PASTEL ON PAPER, 30 × 46 CM. C.1869. PARIS, LOUVRE

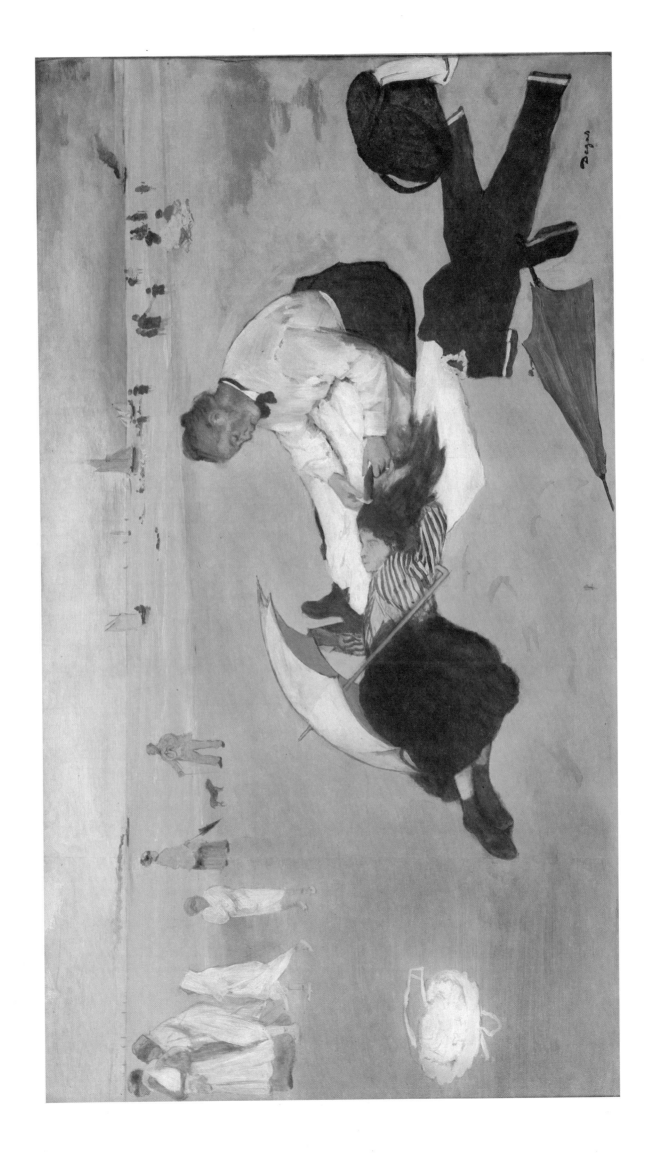

Carlo Pellegrini

WATERCOLOUR, PASTEL AND OIL ON PAPER, 63 × 34 CM. C.1876–7. LONDON, TATE GALLERY

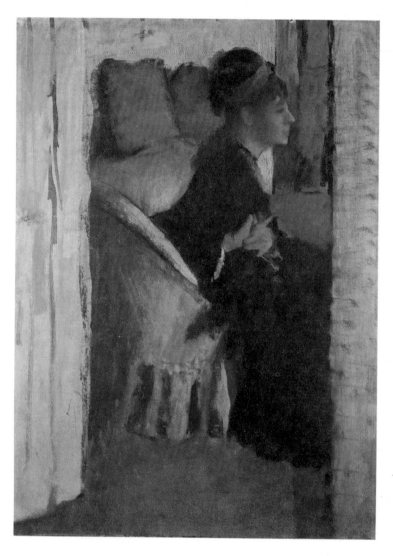

Carlo Pellegrini, an Italian cartoonist, moved to England in 1864; in the 1870s and 1880s he became well-known as a contributor to *Vanity Fair*, under the pseudonym 'Ape'. Degas's portrait wittily captures a characteristic pose; the boldly high viewpoint emphasizes the jaunty silhouette. In an undated letter Degas refers with admiration to a caricature that Pellegrini had made of him; this portrait, inscribed 'à lui Degas' was apparently Degas's reply. It has been suggested that Degas based the lively stance of his figure on one of Pellegrini's own drawings; the vigour of the shapes and the strong element of caricature seem to lead on to Toulouse-Lautrec. Degas was a brilliantly acute observer of the apparently trivial yet habitual gesture. The flamboyance of this work contrasts with the quiet mood of the *Woman Putting on her Gloves* (Fig. 24), yet in both the attitude of the body and the apparently insignificant detail – a pudgy hand grasping a cigarette, a woman carefully drawing on gloves – are made to convey character just as much as the face.

Fig. 24 (left)
Woman Putting on her Gloves

CANVAS, 60.9 × 46.9 CM. C.1877. PRIVATE COLLECTION

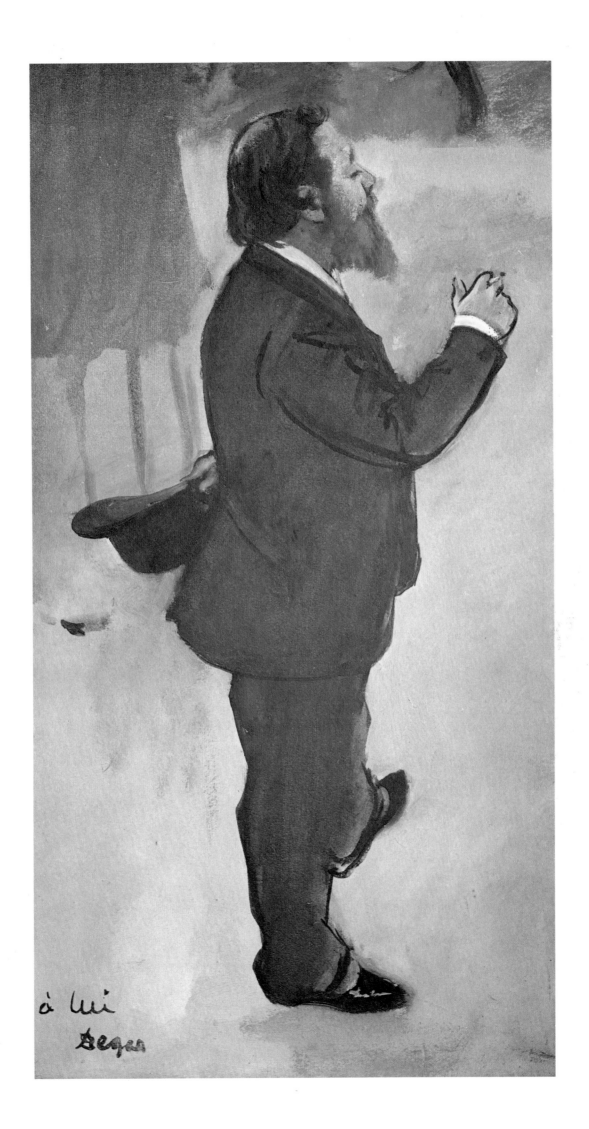

Café-Concert at the 'Ambassadeurs'

PASTEL OVER MONOTYPE ON PAPER, 37 × 27 CM. C.1876–7. LYONS, MUSÉE DES BEAUX-ARTS

This small picture captures brilliantly the noisy atmosphere of the open-air café-concert which Degas enjoyed at the Théâtre des Ambassadeurs on the Champs Elysées. The immediacy of the image is cunningly contrived: we seem to catch a glimpse of the singer over the heads of the crowds – the eye is drawn to her by the red glow of her dress, and by the extraordinary juxtaposition of the curving scrolls of the double-bass and the lines of her skirt. The startling effects of artificial light – the sharp glare of the footlights contrasted with the glow of the gas globes – add to the vividness of the scene; yet the row of lights is subtly extended by the line of the singer's arm, and the brilliant colours of the women's hats reflect the colours on the stage. The contrast of directions with-

in the picture – the line of the instruments, the singers waiting to appear looking out to the left, the jostling, wittily observed movements of the crowd – suggest a random moment, yet these movements are contained by strong diagonals and rectangles. The theme of the café-concert particularly attracted Degas in the years 1876–8; in a notebook of 1878 he jotted down 'an infinite variety of subjects in the cafés, different tone values where the globes are reflected in the mirrors.' Many of his treatments of the theme are monotypes. There is a similar quality of witty observation and interest in artificial light in the monotypes of brothel scenes dating from 1878–9. This pastel (Fig. 25) was shown at the third Impressionist Exhibition of 1877.

Fig. 25
Three Girls in the Reception Room

MONOTYPE, 11.8 × 16 CM. 1877–9.

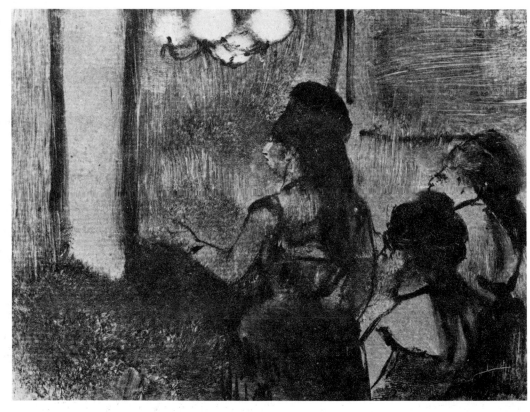

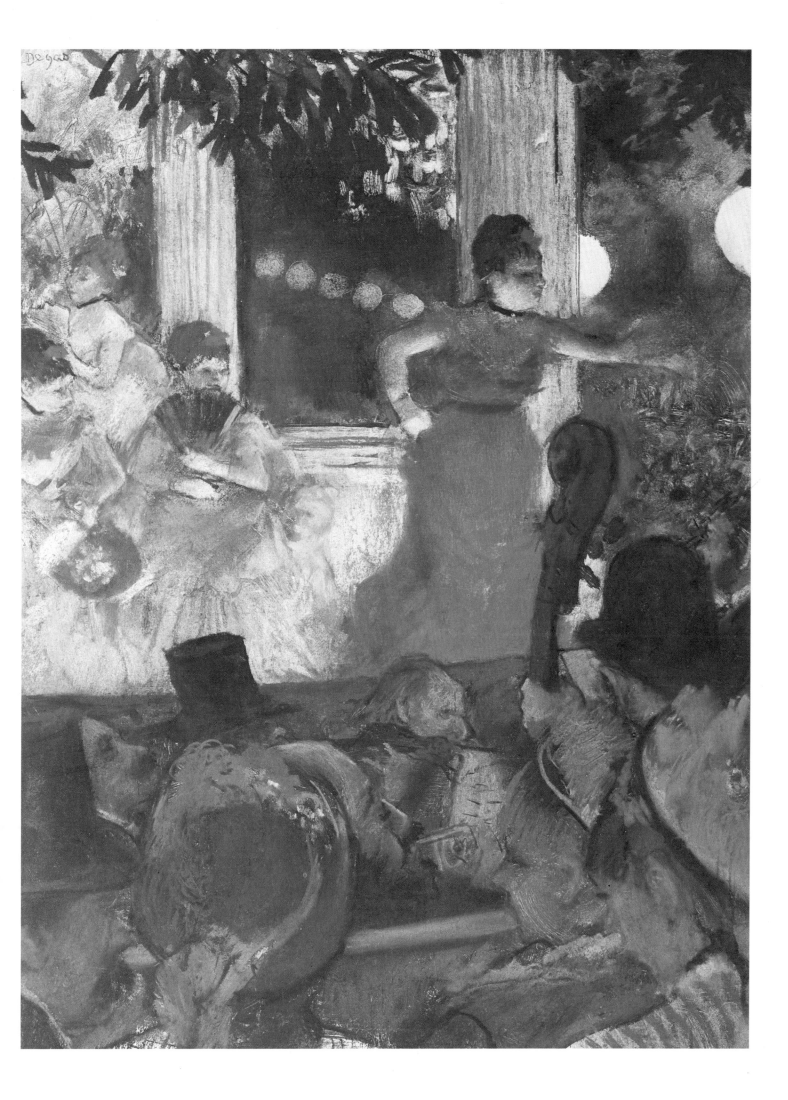

Dancer with a Bouquet Bowing

PASTEL ON PAPER, 75 × 78 CM. C.1877. PARIS, LOUVRE (JEU DE PAUME)

Degas's early ballet paintings showing crowded practice rooms, delicately coloured and coolly lit, were followed by a series of pastels which show the dancer on the stage. Here, her performance at an end, and a large bouquet of flowers in her hand, the ballerina curtsies to an unseen audience. The group of figures behind her occur as a detail in the earlier *Musicians in the Orchestra* (Plate 12), where the brilliant light of the stage contrasts with the darkness of the foreground. Here the magical effect of artificial light, which catches the figure from below, has become the artist's main interest. Yet, despite the exotic set and intense colour, there is a touching sense of the reality behind the glamour of the theatre. The curtsey of the ballerina suggests effort, and her deeply shadowed face, exhaustion. On one side the dancers remain posed, but behind the ballerina a dancer rubs her back, while another, cut off by the frame, thrusts out her foot awkwardly. Degas painted many variants of this composition, and this version was probably shown at the third Impressionist Exhibition of 1877.

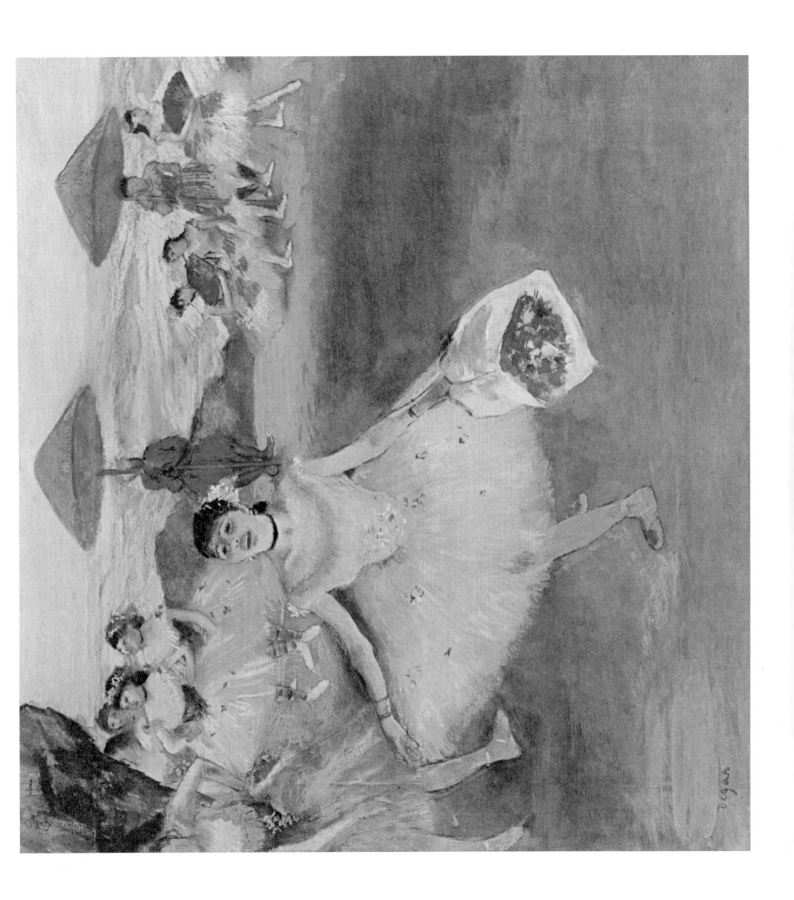

Amateur Jockeys on the Course, beside an Open Carriage

CANVAS, 66 × 81 CM. C.1877–80. PARIS, LOUVRE (JEU DE PAUME)

The first group of Degas's jockey scenes dates from about 1868–73; he returned to the theme in the early 1880s when he developed the analysis of movement even more rigorously. The series as a whole is distinguished by large areas of flat colour setting off the nervously drawn figures of the racehorses. This picture from the mid-1870s is rather different. It has a rich variety of colour and texture, and a sense of lively, jostling movement; the jockeys and spectators are strongly and wittily characterised – one evidently straining to control a bolting horse. (Compare these amateur jockeys with the faceless professionals in Plate 40.) Here Degas has been attracted to the racing scene not so much by the movements of the horses, but as part of the brilliant spectacle of contemporary life that so fascinated him throughout this decade; the little town on the hillside and the glimpse of a steam-train suggest a modern setting. His interest in every aspect of the racing scene extended to the grooms who looked after the horses (Fig. 26). The vivid immediacy of the picture depends on the variety of actions that occur simultaneously; the figures are deliberately unconnected and look in different directions; the carriage and spectator on the right are cut into by the frame. The picture has much in common with Degas's scenes of Parisian night-life of 1876–8, for throughout the 1870s he sought a new pictorial structure that would capture the rapid rhythms of modern life.

Fig. 26 (right)
Four Studies of Grooms

OIL ON PAPER, 37 × 24 CM. 1875–7. ZURICH, MRS MARIANNE FEILCHENFELDT

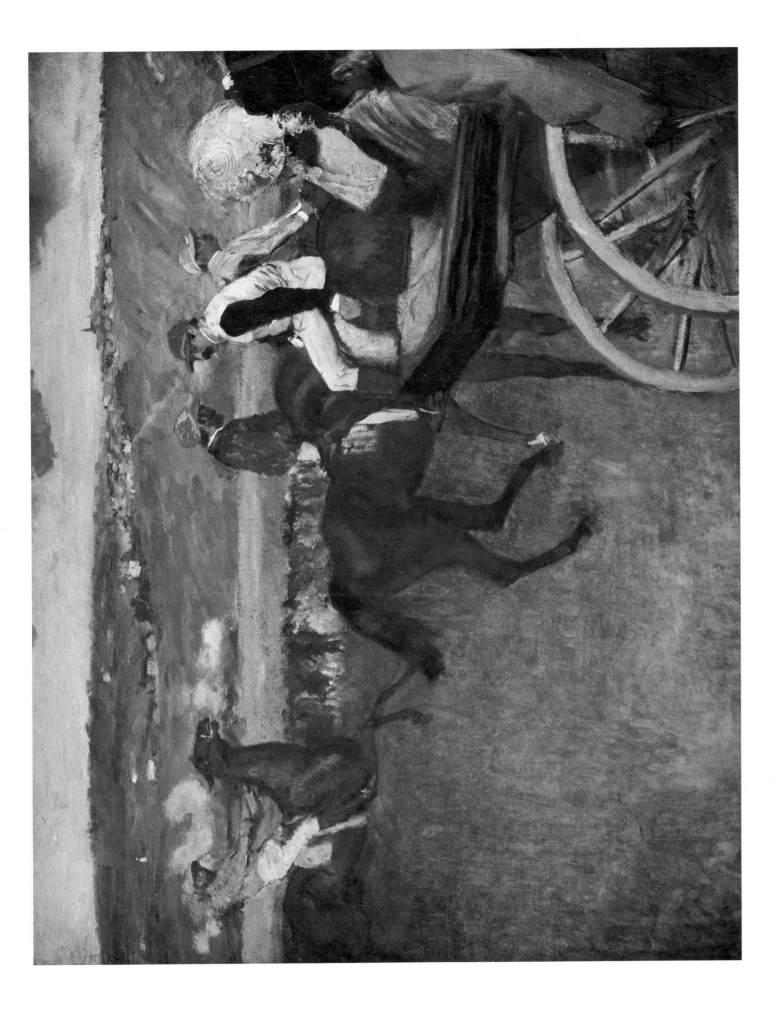

Dancers Rehearsing

PASTEL AND CHARCOAL ON PAPER, 49.5 × 32.25 CM. C.1878. PRIVATE COLLECTION

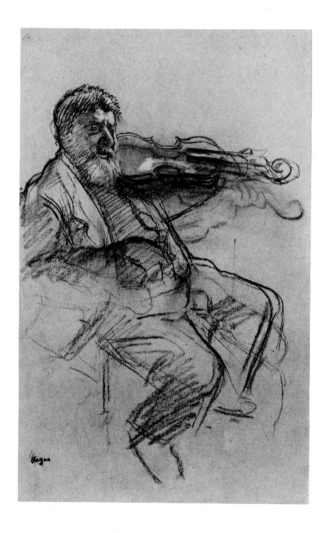

Degas made many preparatory drawings for his ballet paintings. *The Violinist* (Fig. 27) is a wonderfully broad and rich charcoal drawing of a musician who often accompanied the dancers at ballet rehearsals and classes. It probably dates from around the same time as the *Portrait of Diego Martelli* (Plate 34), and has the same kind of power; the confused lines around the violin show how energetically Degas sought out the exact position. *Dancers Rehearsing* (Plate 28) is one of several pastel studies of girls preparing for, or resting from, a rehearsal. The figure is seen from behind, unaware of the spectator. The study was used in *The Dance Class*, which was exhibited at the fifth Impressionist Exhibition of 1880. This is one of a group of pictures of similar format and size; Theodore Reff has pointed out that there is a sketch for a variant of the composition with an exaggeratedly large double-bass in a notebook of 1879, and Degas may have begun to work on the series in that year (Fig. 8). In these works there is less stress on the individual dancers than in earlier rehearsal scenes; the compositions are extended horizontally until the contrasting poses of the figures attain a kind of decorative beauty.

Fig. 27 (left)
The Violinist

CHARCOAL, 41.9 × 29.8 CM. C.1879. BOSTON, MUSEUM OF FINE ARTS

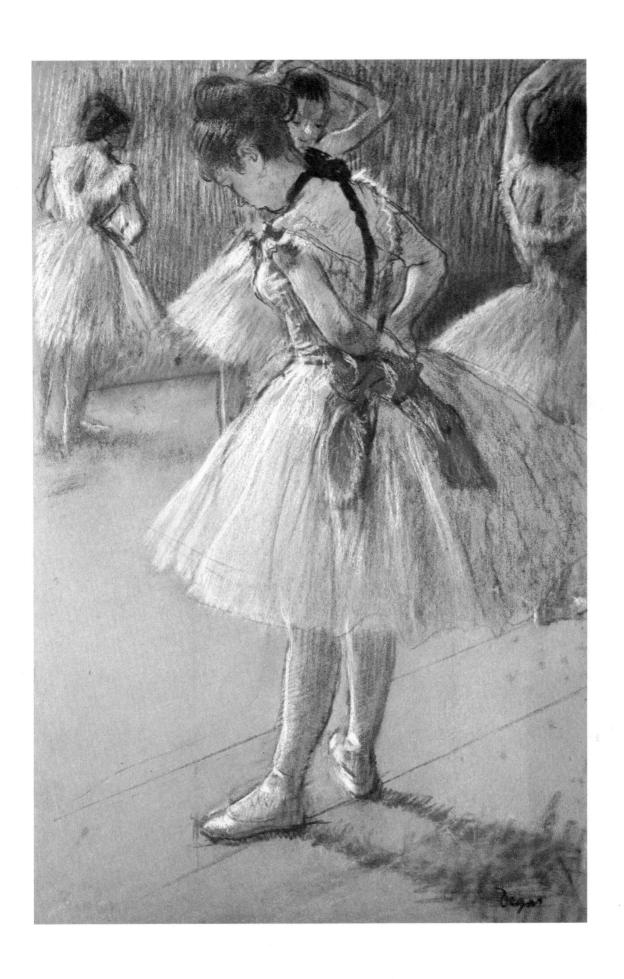

Café Singer

PASTEL ON CANVAS, 53 × 41 CM. C.1878. CAMBRIDGE, MASSACHUSETTS, FOGG ART MUSEUM

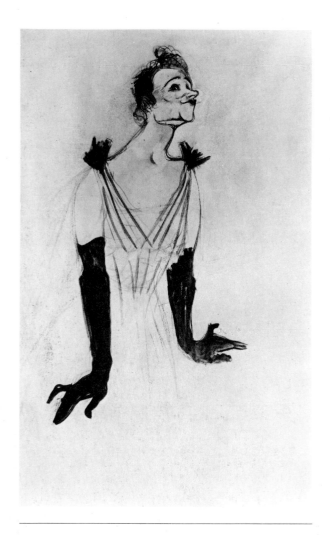

Fig. 28
HENRI DE TOULOUSE-LAUTREC
Yvette Guilbert (Study for a Poster)

PENCIL AND OIL, 186.1 × 93 CM. 1894. ALBI, MUSEE TOULOUSE-
LAUTREC

Degas was fascinated by the characteristic gestures of the singer at the café-concert; he liked the effects of artificial light that so strangely transform the vulgar features of the face. In this dramatic close-up the singer, Mademoiselle Desgranges, is brilliantly caught in mid-performance. Preparatory studies reveal how Degas heightened the immediacy of the image by bringing the body closer to the plane and lopping off the left arm. By emphasizing the low viewpoint he extended the boldly expressive silhouette of the long black glove; the pallor of the colours seems to separate it from the body, and it is outlined against vertical strips of browns and green. In a letter of 1883 Degas wrote, 'Go at once to hear Theresa at the Alcazar... She opens her large mouth and there emerges the most roughly, the most delicately, the most spiritually tender voice imaginable. And the soul, and the good taste, where could one find better?' Degas's painting is equally ambiguous; there is satire in his treatment of the large mouth and chin, and yet the figure is powerful and dramatic. This picture was exhibited at the fourth Impressionist Exhibition of 1879, with *Miss La La* (Plate 31). Both pictures show Degas moving away from the witty social comment of the 1870s towards the more monumental and concentrated works of the 1880s.

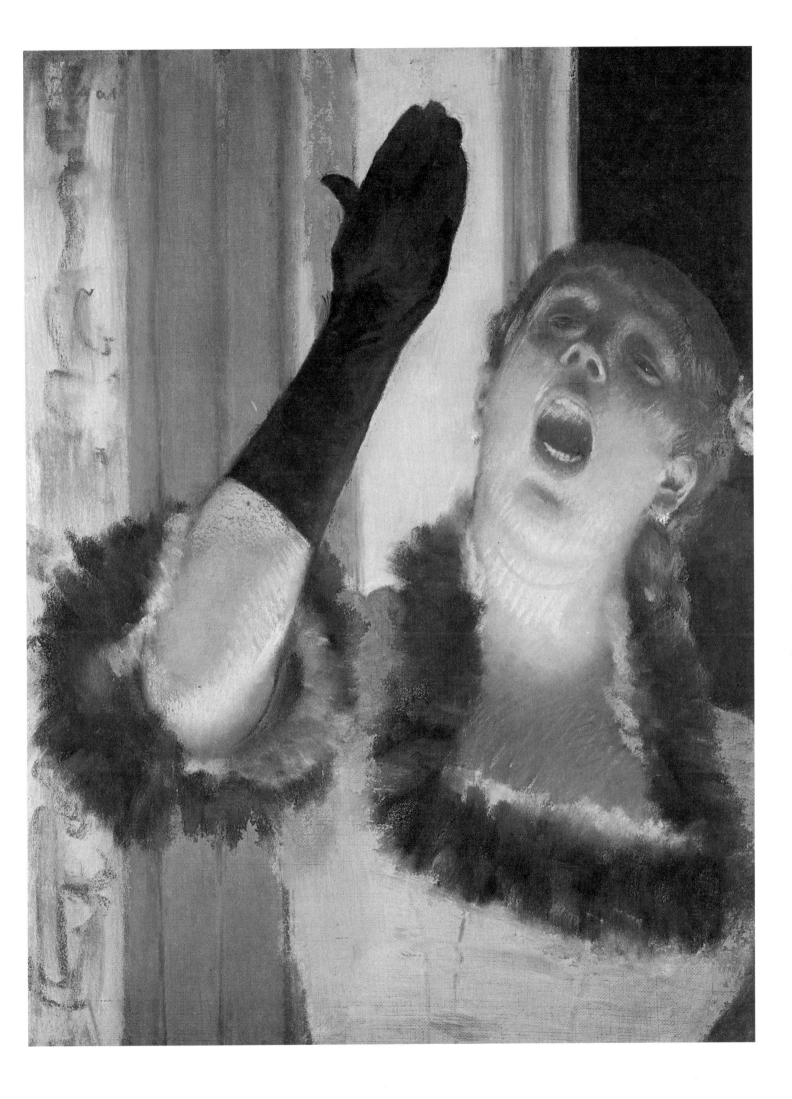

Dancer on the Stage

PASTEL ON PAPER, 60 × 43.5 CM. 1878. PARIS, LOUVRE (JEU DE PAUME)

Like *Two Dancers on the Stage* (Plate 18), this picture of a ballet in performance is in a vertical format with a huge area of empty foreground; the figure is seen from above, and her pose is contrasted with the diagonal line of the stage scenery. But whilst the *Two Dancers* implied movement impending from a moment of static balance, this painting – usually called 'l'Étoile' – catches movement in full flight. This famous figure of a dancer floating through one of the most graceful of all the positions of classical ballet epitomizes all the grace, charm, and excitement at techniques that we still feel at ballets like *Giselle*. The figures watching in the wings, and especially the man in evening-dress, with his hands in his pockets, suggest the brevity of the moment and remind us that this is all an expensive illusion. The picture is worked in pastel, which Degas found an ideal medium for depicting ephemeral moments such as this. The pastel is used with a great range of effects, notably in the rich colour of the scenery and the diaphanous delicacy of the dancer's costume, particularly in the flowers.

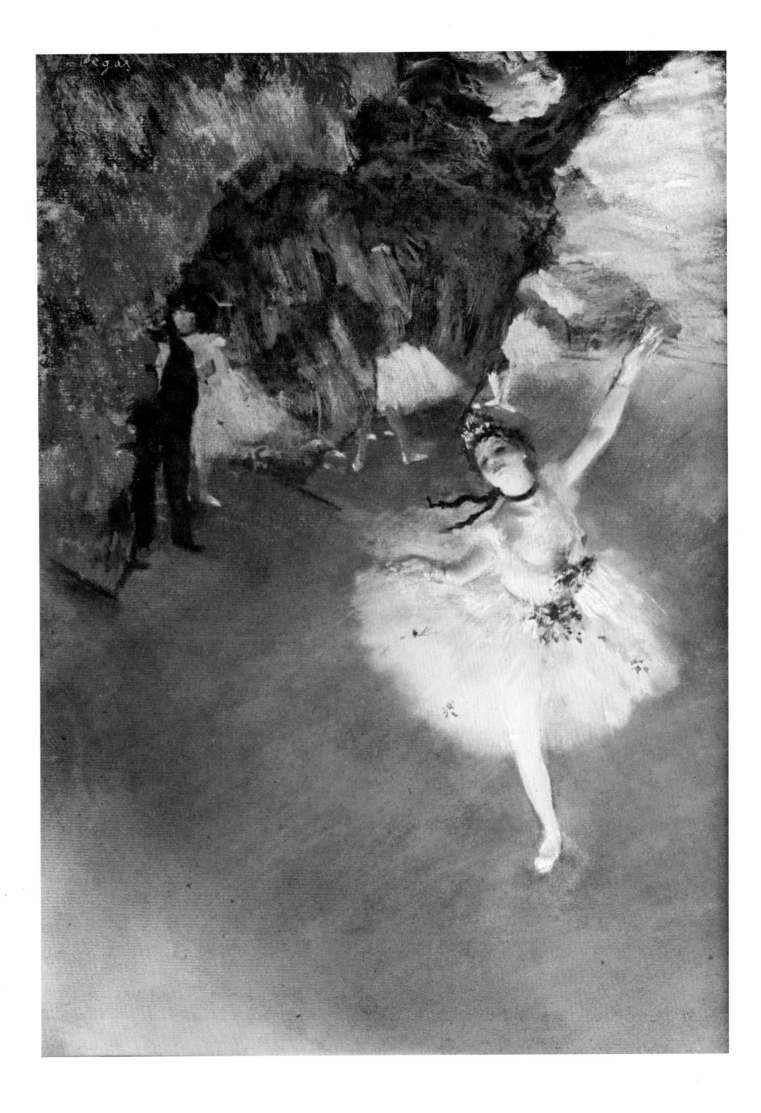

La La at the Cirque Fernando, Paris

CANVAS, 117 × 77.5 CM. 1879. LONDON, NATIONAL GALLERY

Degas made several studies from life of the mulatto acrobat Miss La La when she was performing at the Cirque Fernando on the Boulevard Rochechouart in January 1879; here, a rope clenched between her teeth, she hangs suspended from pulleys on the ceiling. The picture is one of Degas's most startling and breathtaking images of a momentary action. Its vividness is emphasized by the unexpected angle; the rope is cut off at both ends and we are made to share the upward gaze of the spectators in the circus below. Yet the picture's snapshot immediacy is the result of careful preparation and concern for accurate detail. It was preceded by several studies of the figure, in which Degas analyses the weight of the body pulling against the rope, and by many precise studies of the arena, the structure of the wooden roof, and the unexpected effects of artificial light. The painting was exhibited in the fourth Impressionist Exhibition of 1879.

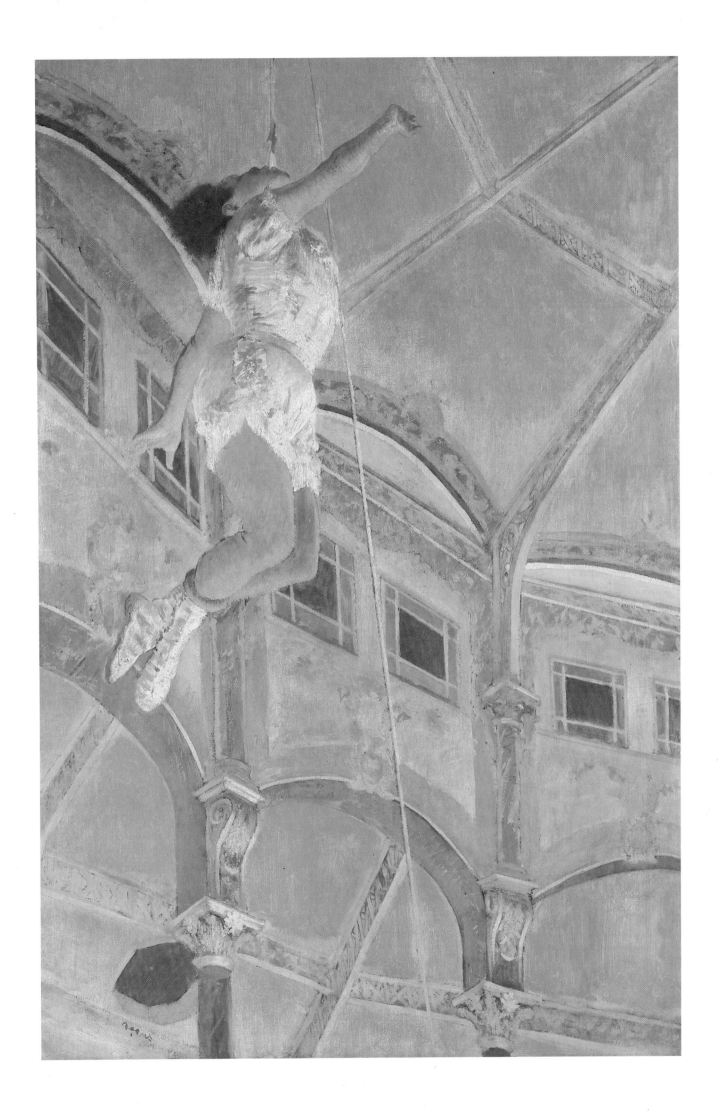

Jockeys before the Race

OIL COLOURS WITH TURPENTINE ON CARDBOARD, 107 × 74.25 CM. C.1879. BIRMINGHAM, BARBER INSTITUTE OF FINE ARTS

The most startling features of this daring composition are the large area of empty space (compare *Two Dancers on the Stage*, Plate 18) and the strange effect of the pole splitting the horse's head in half. This odd effect is used elsewhere – dancers are cut into by stage flats, women are glimpsed behind the pillars of a café – but rarely so dramatically. Degas, perhaps influenced by Japanese prints, has used the starting-pole to divide the surface into geometrical shapes. The grass and sky seem to be bands of colour parallel to the plane, and the flat circle of the sun brings the distance forward. Against this abstract patterning of the surface Degas arranges the horses so that they create a sensation of depth. The pale colours and strange watery light create an almost eerie mood. Ronald Pickvance has shown that this unusually large picture derives from a small panel of 1868, and that it was shown at the fourth Impressionist Exhibition of 1879. This painting, and the *Jockeys in the Rain*, show how Degas frequently re-interpreted themes from his earlier work.

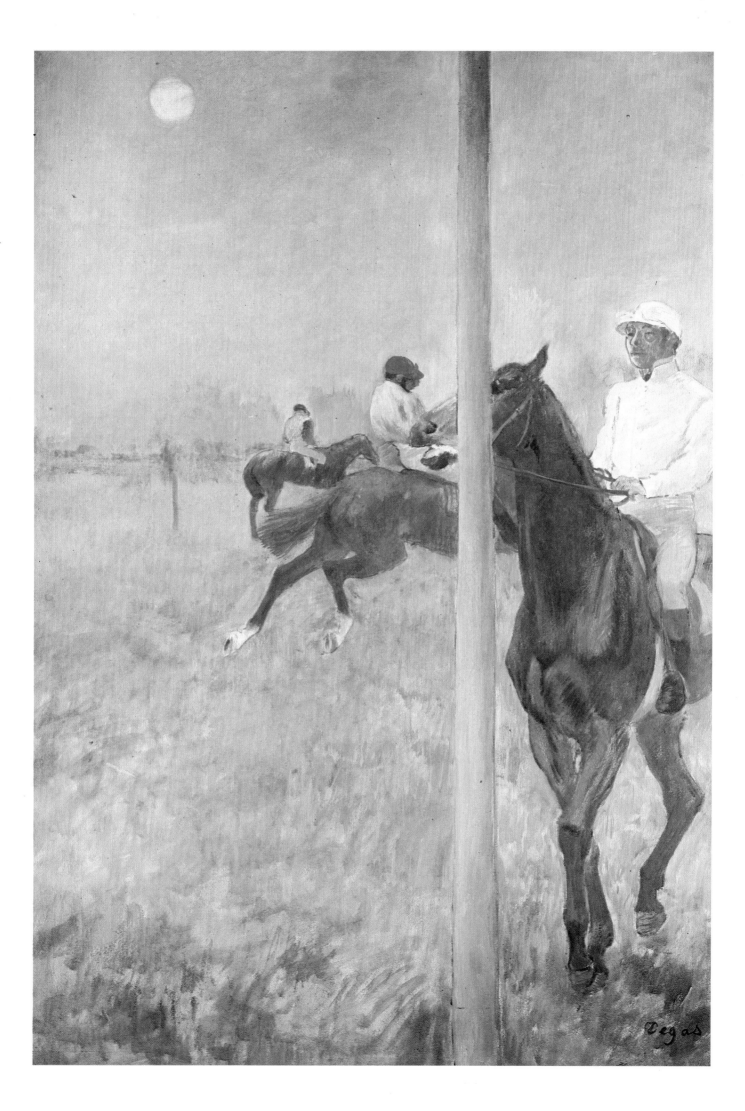

Edmond Duranty

DISTEMPER, WATERCOLOUR AND PASTEL ON LINEN, 101 × 100 CM, 1879. THE BURRELL COLLECTION –
GLASGOW MUSEUMS & ART GALLERIES

The novelist and art critic Edmond Duranty was a close friend of Degas from the early 1860s until his death in 1880. He had played an important rôle in the early development of Realism and Naturalism; his pamphlet, *The New Painting*, may be closely associated with Degas's brilliant rendering of contemporary urban themes in his paintings of the 1870s. The portrait itself seems to reflect the interests that artist and writer shared – the careful description of an everyday setting (Fig. 29), and the revelation of character by pose and expression. Duranty is shown in his study, surrounded by books and prints, apparently caught unawares by the painter in a moment of deep concentration. The sense of a penetrating, restless intelligence is communicated by the tautness of body and hands – most striking are the two fingers pressed against the temple in what must have been an habitual gesture. The painting was shown at the fifth Impressionist Exhibition in 1880 as a tribute to Duranty, who died nine days after the opening. It was reviewed by Huysmans, who saw in the brilliance of the colour – the flecks of green in the beard, the yellow and violet in the hands – evidence of Degas's deep admiration for Delacroix.

Fig. 29
Bookshelves in Duranty's Library

CHARCOAL, HEIGHTENED WITH WHITE CHALK ON BUFF PAPER, 46.9
× 30.6 CM. C.1879. NEW YORK, METROPOLITAN MUSEUM OF ART

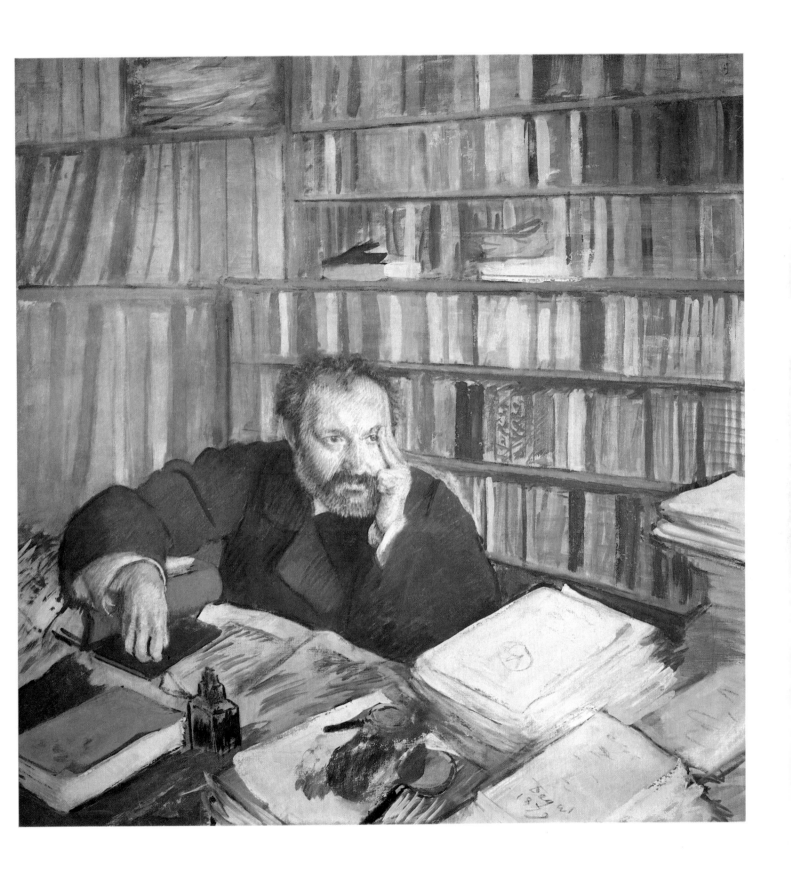

Portrait of Diego Martelli

CANVAS, 107.25 × 100 CM. 1879. EDINBURGH, NATIONAL GALLERY OF SCOTLAND

Diego Martelli, an Italian art critic, may have met Degas in Florence in 1858–9, where he was the leading critic and advocate of the Macchiaoli, a group of painters influenced by the realism of Courbet. Their friendship flourished in Paris in 1878. Martelli, an enthusiastic admirer of Degas's works, was deeply impressed by the fourth Impressionist Exhibition, at which this picture was shown; his lecture on the Impressionists, delivered at Livorno later that year, was one of the first attempts to spread their ideas to Italy. Degas's portrait of his friend is his most daring attempt to convey a vivid personality through a characteristic attitude and a strikingly unconventional composition; the viewpoint is exaggeratedly high and the figure thrust to one side. The portrait brilliantly captures the free, informal atmosphere in which the writer worked. He is shown in his shirt-sleeves, amidst all the disarray of his everyday life; he seems to have turned away from the pile of paper on the table in order better to collect his thoughts. The slippers, left untidily on the floor, are a particularly personal touch. The bold silhouette of the figure is emphasized by the blue of the sofa: the curves of the body are echoed by the curves of the sofa and picture. This is perhaps one of the most affectionate of Degas's portraits; the round body of the writer conveys a sense of good humour very different from the nervous energy of Duranty (Plate 33).

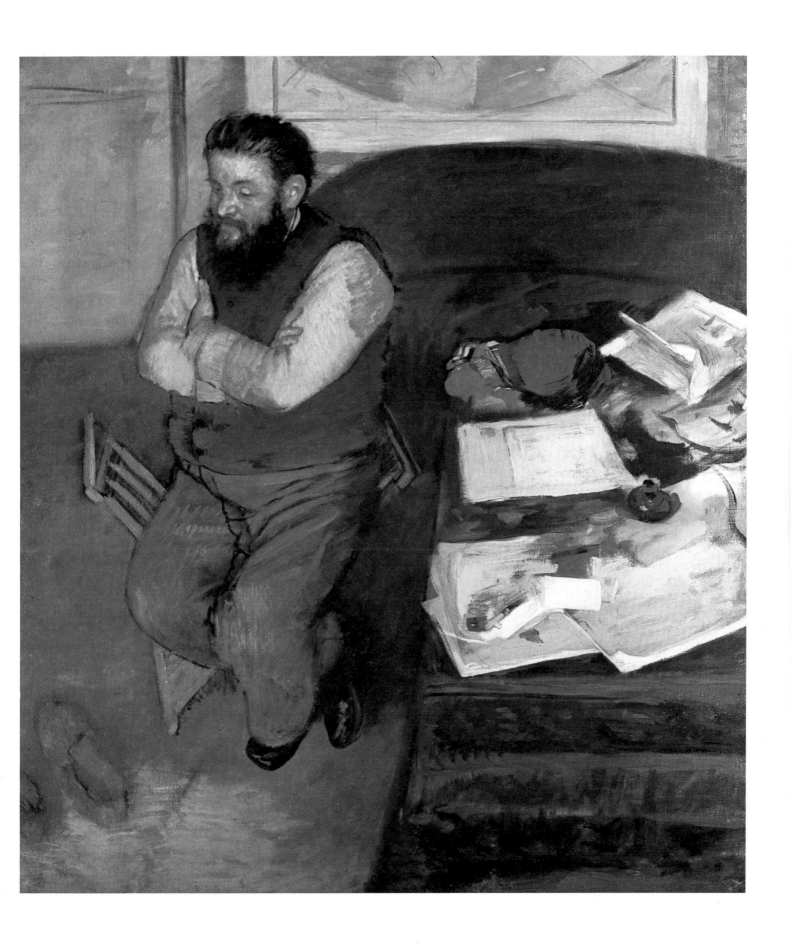

Woman Ironing

CANVAS, 81 × 66 CM. C.1880. LIVERPOOL, WALKER ART GALLERY

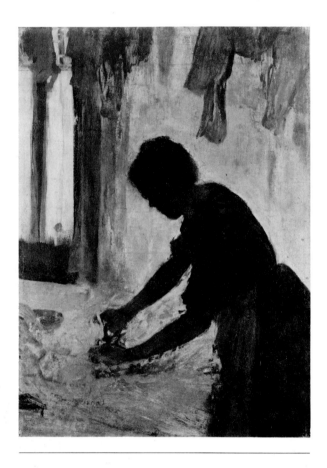

Fig. 30
Woman Ironing

OIL ON CANVAS, 54 × 39 CM. 1874. NEW YORK, METROPOLITAN
MUSEUM OF ART

Degas began his series of laundresses and women ironing in 1869. He was attracted by the rhythmic gestures that their work demanded, and by the unexpected effects of bright sunlight in the hot, steamy atmosphere of the laundry-room. In 1872 he wrote from New Orleans, 'Everything is beautiful in this world of the people. But one Paris laundry girl, with bare arms, is worth it all for such a pronounced Parisian as I am.' Degas first experimented with the pose and the brilliant *contre-jour* effects of this painting in a smaller oil now in the Metropolitan Museum, New York (*c.* 1872; Fig. 30); in the Liverpool picture the tenseness of the woman's body makes more apparent the pressure that she is exerting. Ronald Pickvance has suggested that it was designed in the early 1870s and reworked around 1880. Whatever its date, the work shows many of Degas's preoccupations stripped to their bare essentials. The monumental figure, painted in blocks of only three main colours, is firmly locked into place by the strong diagonal of the ironing-board. The background is reduced to vertical bands; not even the eyes are shown on the model's expressionless face. The austerity of the design, softened by the subtle tonality, and the theme of quiet concentration on a domestic task, recall seventeenth-century Dutch genre painting. This style had deeply influenced French Realists in the 1850s and 1860s, and Bonvin's *Woman Ironing* (1858; Philadelphia) anticipates Degas's stress on the woman's activity.

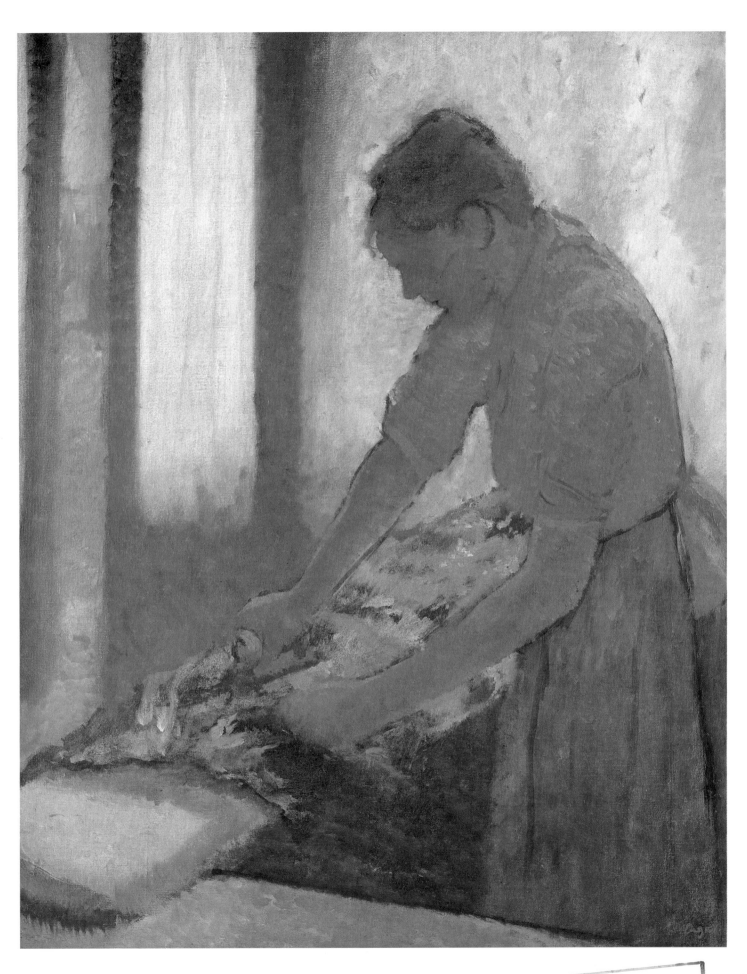

MERTHYR TYDFIL
TECHNICAL COLLEGE
LIBRARY

After the Bath

PASTEL ON PAPER, 53 × 33 CM. C. 1883. PRIVATE COLLECTION

Baudelaire in 1846 had lamented that the artist did not 'paint the modern beauty of the nude' in everyday contemporary situations — in bed, for example, or in the bath, or in the anatomy theatre'; he described 'Rembrandt's Venuses who are having their hair combed with great boxwood combs, just like simple mortals'. Degas's late series of pastels of the nude in an everyday setting splendidly fulfil Baudelaire's demand. He began the series in about 1880 and the main characteristics were there from the start: the figures are unaware of the observer, usually seen from behind, absorbed in their toilet, often caught in unstable poses in mid-movement. As the series progressed the drawing became looser and the colours richer. This picture of about 1883 is typical of all the main themes of the series but its content is more closely related to earlier painters than Degas's later nudes. The pose is characteristic, but the buttocks, the taut drawing of back and breast, and the trim turn of the head are all reminiscent of an earlier French School's idea of what a pretty young girl should look like. There is something of Boucher, too, in the freshness and lightness of the colouring of this charming picture.

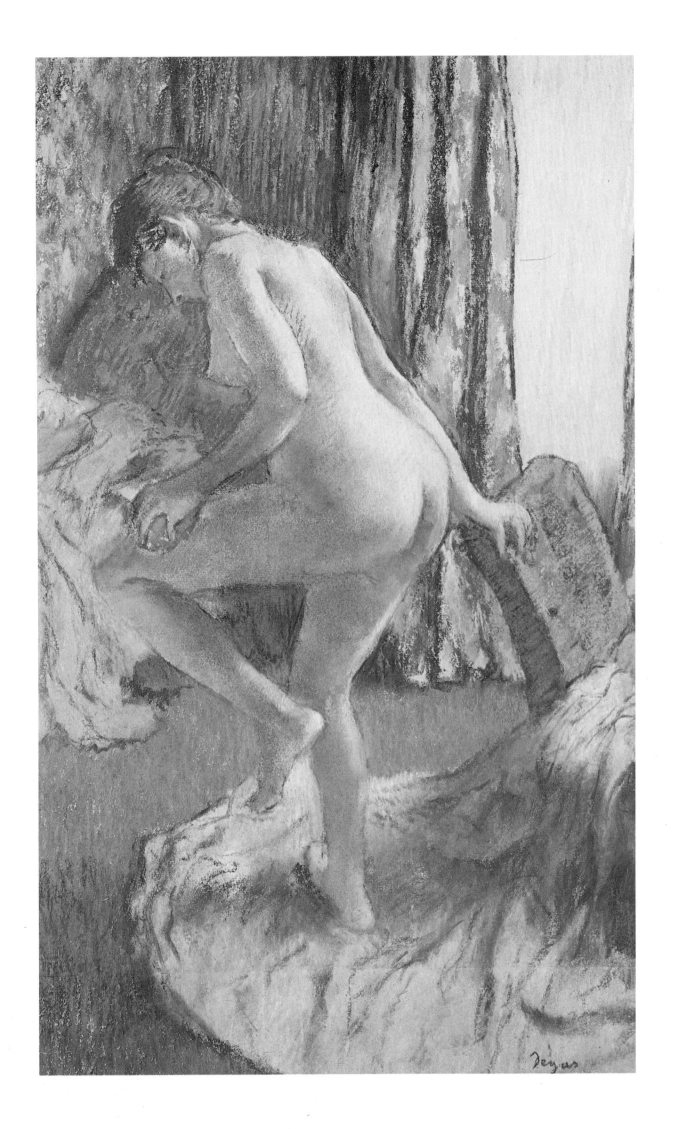

Scene in a Laundry

PASTEL ON PAPER, 63 × 45 CM. C.1884. THE BURRELL COLLECTION – GLASGOW MUSEUMS & ART GALLERIES

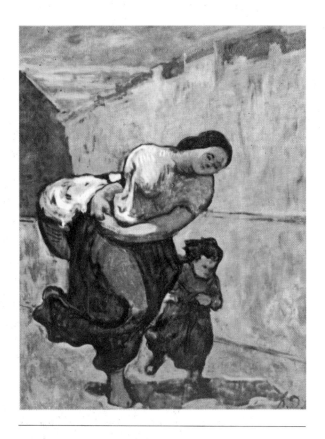

Fig. 31
HONORÉ DAUMIER
The Burden

OIL ON CANVAS, 147 × 95 CM. C.1860. PRIVATE COLLECTION

Degas's earliest laundry scenes analyse the movements involved in ironing and tend to show single figures. The pictures from the 1880s usually show two women in contrasted attitudes, as in this pastel. This is a psychologically and formally complex work with a number of aspects that jostle for our attention. In formal terms, there are the familiar strong verticals with the two figures arranged along an equally strong diagonal. Psychologically, there is a dramatic and anecdotal element; the two women pause in their work and ease their aching backs. It is a token of Degas's enigmatic quality that there have been several suggestions as to what exactly the woman in yellow is doing. Degas does not, as Daumier would have done, stress their hardship and poverty. Daumier's *The Burden* (Fig. 31) shows the woman weighed down by the heavy load of washing; she has become a symbol of suffering humanity. In Degas's picture the overwhelming impression is rather of startling and even arbitrary colour, as though the laundry, with its humid atmosphere, was a conservatory full of exotic plants. Perhaps in the last resort the peculiar force of this work flows from the tension between subject-matter of extreme social realism and a colourism as turbulent as that of Odilon Redon.

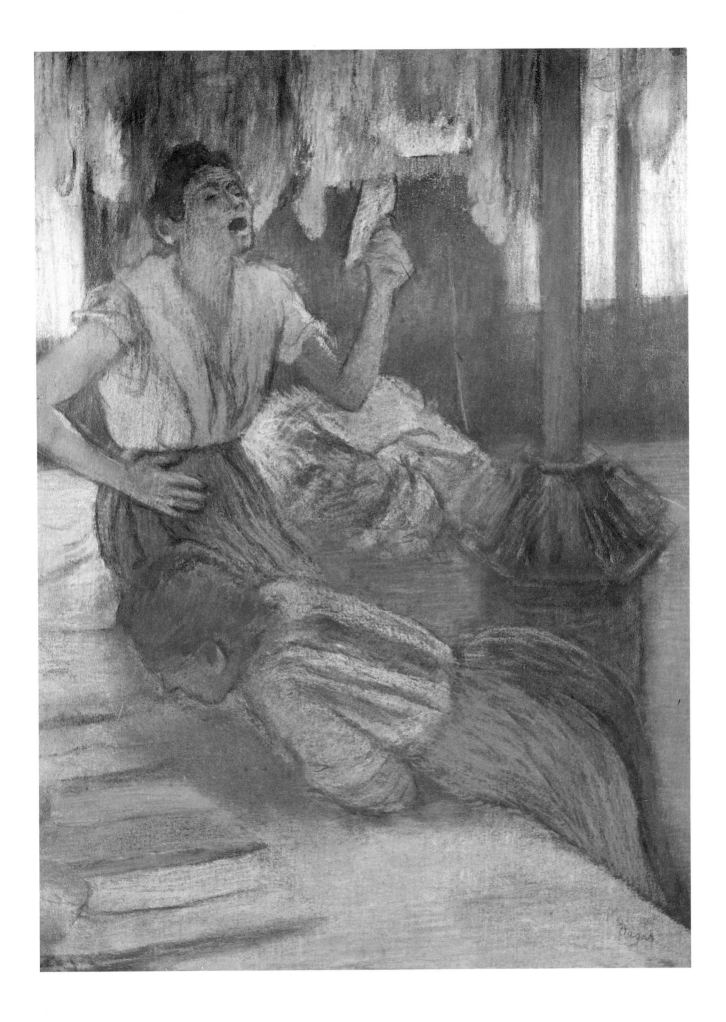

Two Laundresses

CANVAS, 73 × 79 CM. C. 1884–6. PARIS, LOUVRE (JEU DE PAUME)

This is the last of three variations on the same theme. The paint is more brutally applied, the colours stranger, and the figures themselves coarser than in the earlier versions. Degas concentrates on the rich compositional contrast between the powerful gestures of the two massive figures. One stops to yawn, her hand on the bottle that held water for sprinkling, her angular movements contrasting with the rounded back of her companion, who presses with all her weight on the iron. As early as 1874 Edmond de Goncourt had recorded how Degas 'showed me, in their various poses and graceful foreshortening, washerwomen and still more washerwomen ... speaking their language and explaining the techniques of different movements in pressing and ironing.' Degas here puts more emphasis on the human side; the lumpish, almost caricatured figures suggest a Realist novel – Zola's *L'Assommoir* reveals the same kind of detailed knowledge of the laundry. The prostitute was another subject that interested Degas and the Naturalist writers. Degas's sharply observed and witty treatments of women working in brothels are close in feeling to this painting (Fig. 32).

Fig. 32 (right)
'Repos Sur Le Lit'

MONOTYPE, 16 × 12 CM. 1878–9.

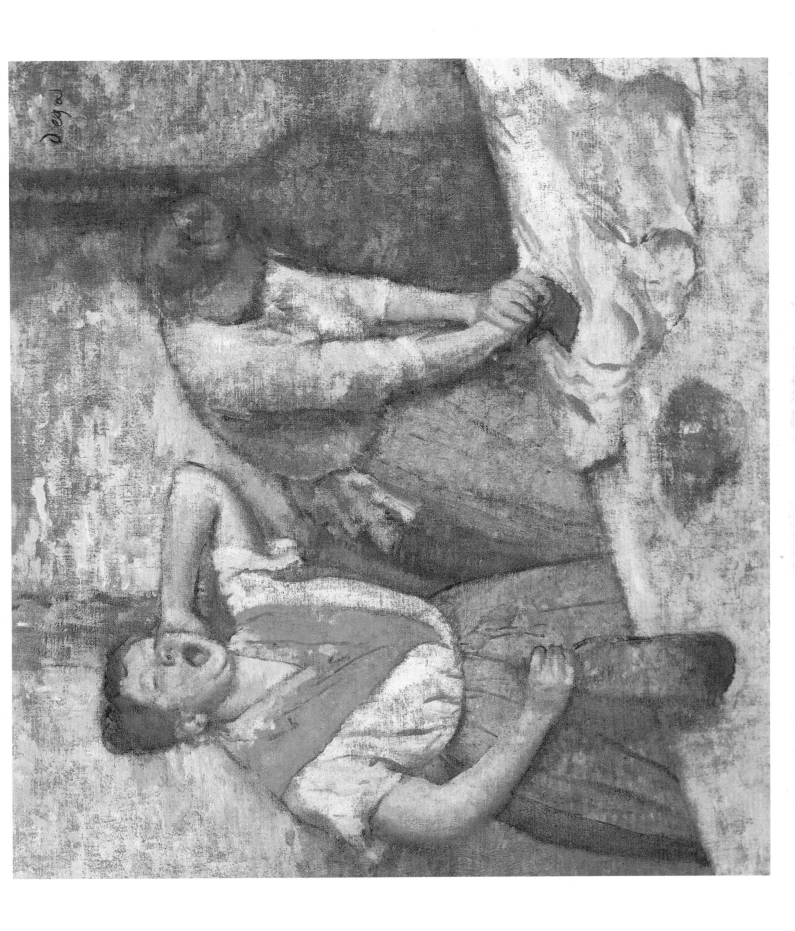

The Millinery Shop

PASTEL ON PAPER, 100 × 111 CM. C.1884. CHICAGO, ART INSTITUTE

This is one of a small series of milliner's scenes produced during the 1880s. Like Proust's Elstir, Degas was very interested in the world of women's fashion and is known to have accompanied Mary Cassatt and other women friends on their shopping trips. Most of the series show fashionably dressed women trying on hats. In this pastel, however, the only figure is the shop assistant – a great deal more elegant than the laundry girls, but, all the same, clearly a working girl doing a skilled job. She is tucked behind the real subject of the work, the display of hats in the shop window seen from a startlingly high viewpoint. The hats themselves – blue, orange, crimson – seem like enormous flowers, too heavy for their delicate stalks, or tropical fish floating across the window of an aquarium.

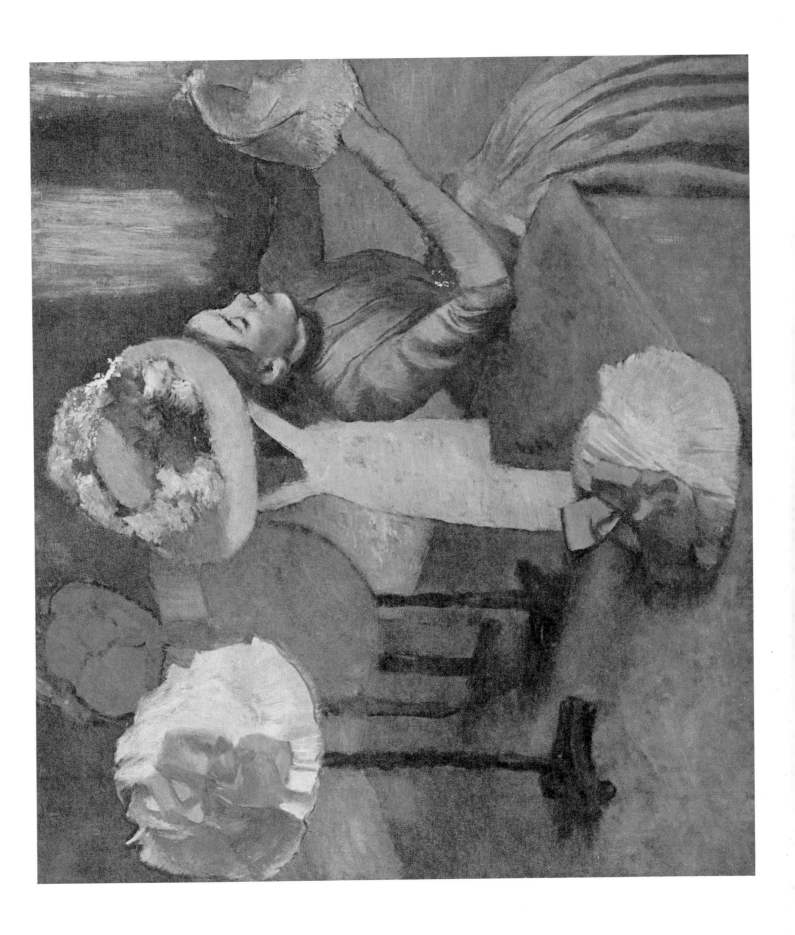

Jockeys in the Rain

PASTEL ON PAPER, 47 × 65 CM. C.1886. THE BURRELL COLLECTION – GLASGOW MUSEUMS & ART GALLERIES

Degas's enthusiasm for the racing scene revived in the 1880s. He was perhaps stimulated by Muybridge's photographs of the horse galloping and trotting, and his late paintings of jockeys and horses concentrate on a precise analysis of movement. This is perhaps Degas's most beautiful rendering of the refined elegance of the thoroughbred, which he described in a poem as 'Tout nerveusement nu dans sa robe de soie.' The bold use of empty space suggests a snapshot informality – and yet this only thinly veils our awareness of the subtle precision with which Degas has balanced the movements of the horses, and set a triangle of empty space against a triangle filled with movement. The immediacy of the scene is emphasized by the falling rain, a motive perhaps suggested by Japanese prints, and one which had also interested Van Gogh. The long diagonal strokes contrast with the rough scribbles of bright colour on the jockeys' sleeves and hats. Ideas for this composition first appear in Degas's drawings of 1866–72; Ronald Pickvance has demonstrated that, like *Jockeys before the Race* (Plate 32), the composition goes back to a small panel of 1868.

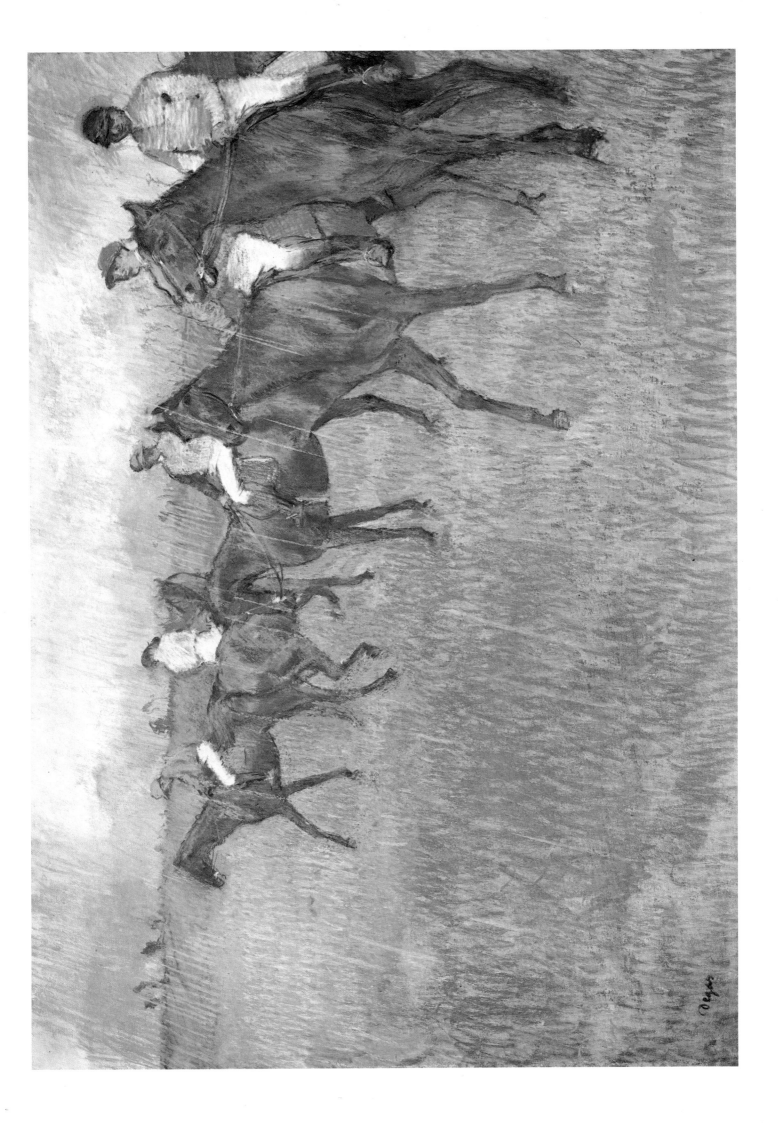

After the Bath: Woman Drying Herself

PASTEL ON PAPER, 104 × 98.5 CM. 1883–90. LONDON, NATIONAL GALLERY

This is the most elaborate of three paintings of the same motive: an undressed woman, seen from behind, one arm raised as she vigorously towels her neck. Degas was attracted by the awkward pose that reveals the tensions of the body. The pull of the arms twists the model and creates a pattern of sharp angles across the surface. The raised right shoulder, which creates a furrow of black shadow in the back, brings out the tautness of the muscles within the body. These tensions are heightened by the tensions between surface and depth; the shoulder seems to jut out against the plane, and the brilliant blob of red hair, echoing the colour in the foreground, brings this area of the picture forward. Degas's handling of pastel in the mid-1880s was increasingly rich. Across the centre of the back straight lines of pink cut across the form; the position of the left arm was altered, and scribbles of pastel go over the contour. The contrast with Renoir's painting (Fig. 33) is sharp. The elaborate pose of Renoir's *Bather* seems carefully contrived to display her ample charms for the delight of the spectator. Renoir was not interested in muscle and skin, or in the strong movements of the female body, but in the glowing beauty of her flesh. His nude has the full, sensual beauty of a Titian or a Rubens, emphasized by the rich colour of the surroundings.

Fig. 33
PIERRE-AUGUSTE RENOIR
'La Grande Baigneuse aux Jambes Croisées'

OIL ON CANVAS, 114.9 × 88.9 CM. C.1902–3. PRIVATE COLLECTION

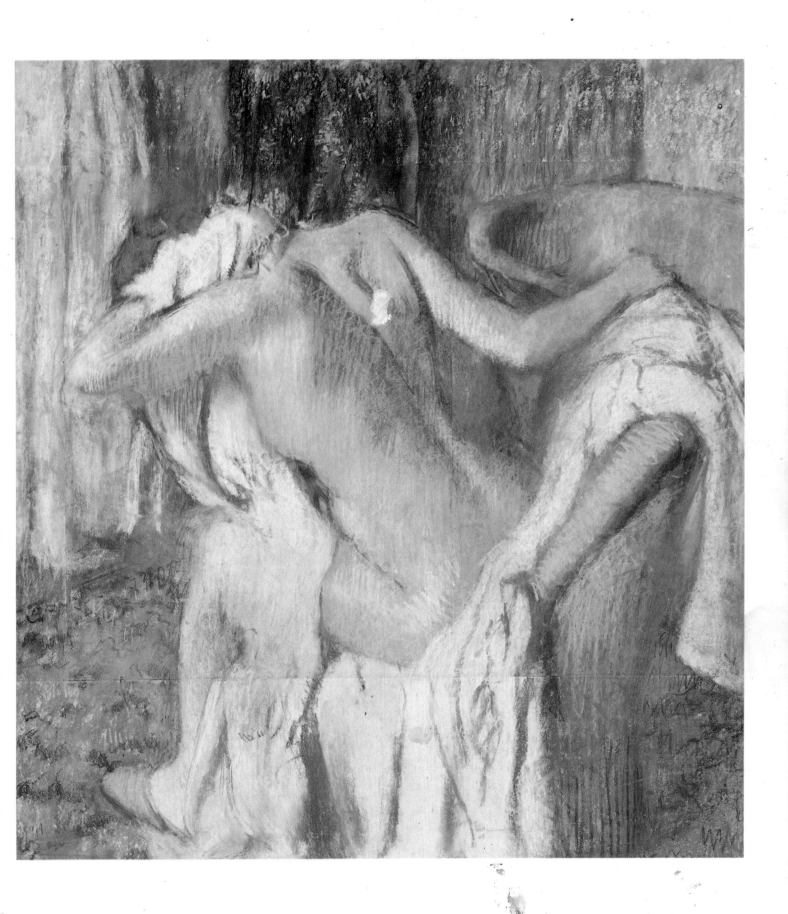

The Tub

PASTEL, 60 × 83 CM. 1886. PARIS, MUSÉE DU LOUVRE (JEU DE PAUME)

Degas contributed a series of ten pastels of the female nude to the eighth Impressionist Exhibition in 1886. He explained his ideas to George Moore: 'Hitherto the nude has always been represented in poses which presuppose an audience, but these women of mine are honest and simple folk, unconcerned by any other interests than those involved in their physical condition... It is as if you looked through a keyhole.' Of all the nudes, this perhaps comes closest to Degas's description. The woman is stripped of the overt charm of the figure in Plate 36; she is painted more coldly, as she crouches like an animal. The spectator looks down at her, as if pausing momentarily in the doorway; the feeling of intrusion on an intimate moment – although lacking any sense of titillation – is very strong. The hard line of the dresser, tilted against the picture-plane, sets off the curves of the woman's back and the soft play of light that runs down her arm; the abrupt division of the surface emphasizes the suggestion of a chance observation. The objects on the dresser seem to press forward and make an insistent claim on our attention; they include a wig and curling-tongs and their stress on mundane activity is perhaps a comment on the traditional iconography of the woman bathing. Despite the aggressive modernity of its presentation, this figure has the weight and balance of antique sculpture. Renoir once said of a charcoal drawing of a nude by Degas, 'It was like a fragment of the Parthenon.'

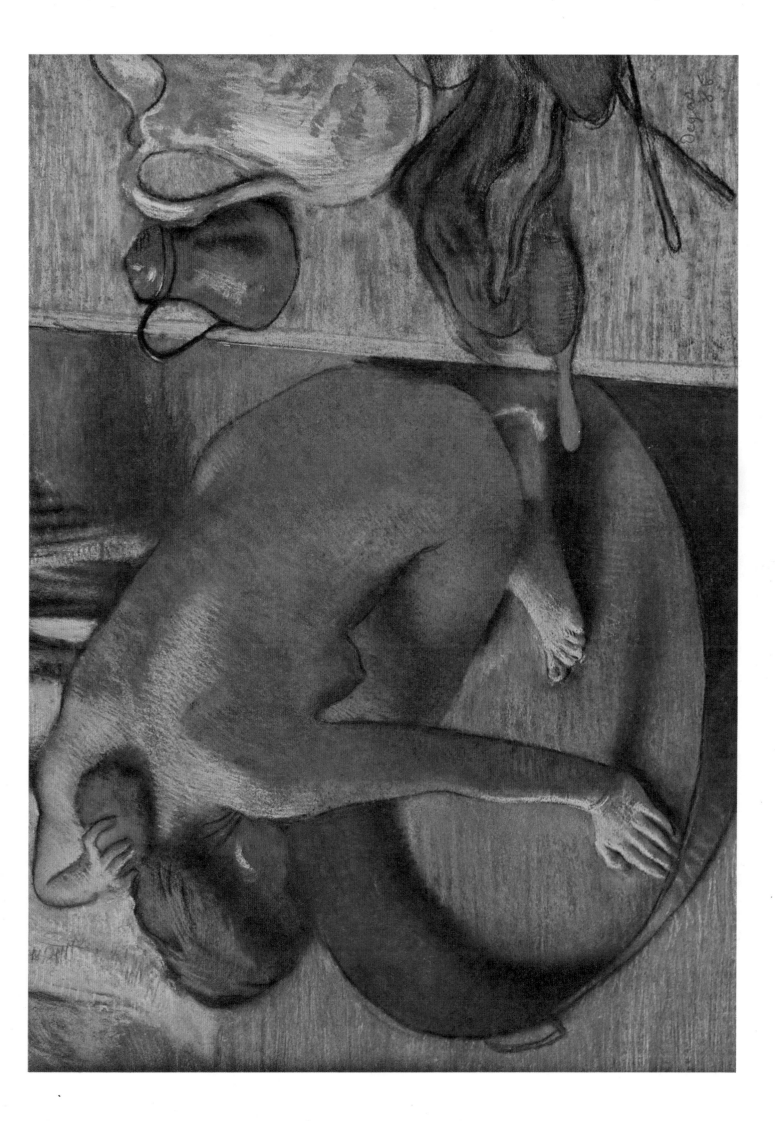

The Bath

PASTEL ON PAPER, 70 × 43 CM. C.1890. CHICAGO, ART INSTITUTE

Degas did several paintings and drawings of the female nude climbing into the bath. Here the complicated, unstable pose is not unlike that of *After the Bath* (Plate 36), yet the line is broader and more powerful, lacking the crisp contours and descriptive detail of the earlier work. The wonderfully rich effects of luminous colour seem to absorb the figure. Degas's treatment of form has become more summary, even abstract; the woman's body, glimpsed over the mass of drapery in the foreground, has become a plane of luminous colour reflecting the dappled greens and blues of the drapery and background. Back and shoulders are flattened out against the plane; the head is a smudge of brown; the contour of stomach and breast is broken into by the brilliant patch of blue light reflected from the curtains. The element of abstraction, the glow of the colour, and the harmony between figure and background lead on to the paintings of Bonnard (Fig. 34) and Vuillard.

Fig. 34 (left)
PIERRE BONNARD
Nude in an Interior after the Bath

OIL ON CANVAS, 73 × 50.2 CM. 1935. WASHINGTON D.C., THE PHILLIPS
COLLECTION

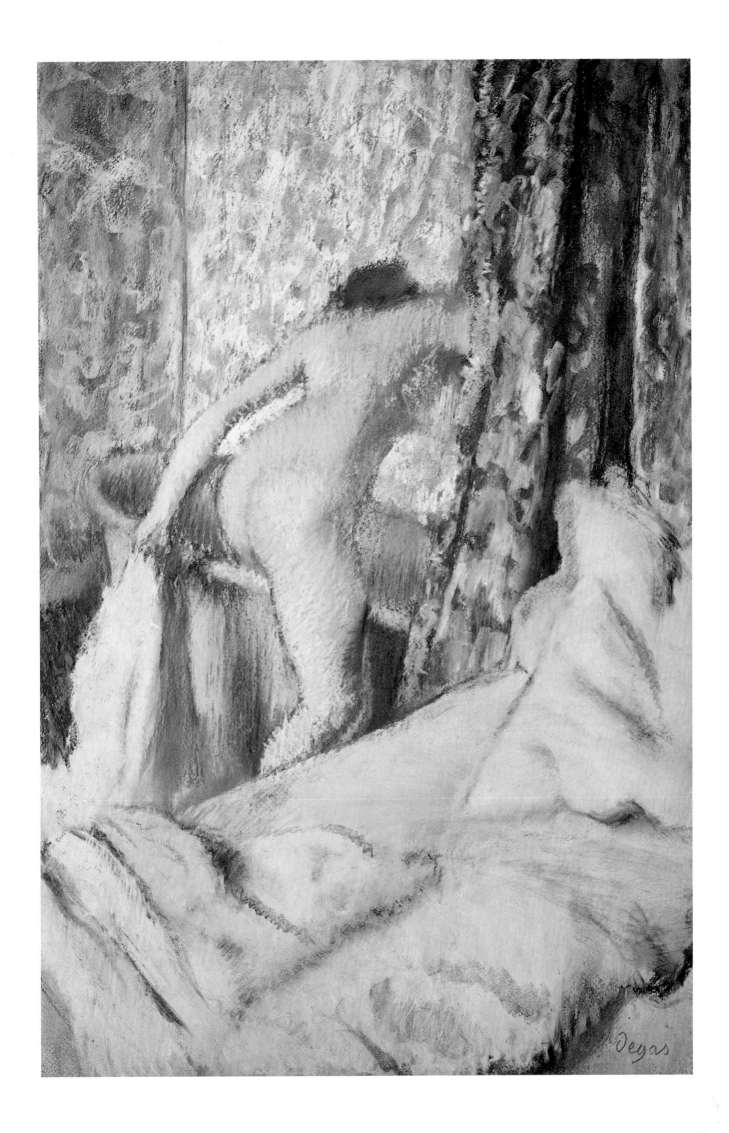

Dancers

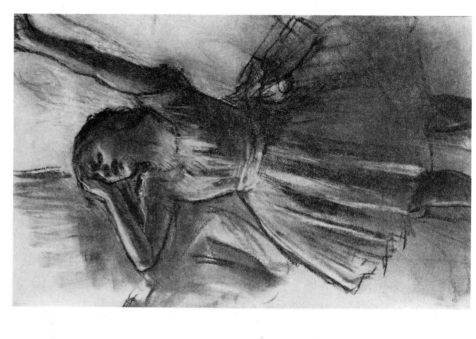

PASTEL ON PAPER, 54 × 76 CM. C.1890. GLASGOW MUSEUMS & ART GALLERIES

From 1879 Degas made many pictures and drawings of dancers at rest – stretching their aching limbs (Fig. 35), resting their head in their hands, or slumped on benches in attitudes of exhaustion. In a group of frieze-like horizontal compositions that may perhaps date from around 1879 Degas contrasted weary dancers resting on benches with others who practise vigorously at the bar. This late pastel isolates and slightly rephrases the foreground group from one of these pictures. Degas has preserved the elements of his earlier composition – the dancers themselves, the figure against a window, the bench – but has drastically simplified them and reduced them to their essentials. The pastel is heavy, and is built up in layers: details have been eliminated and the contours of the figures accentuated. In the background and across the floor the pastel is applied in long strokes that stress the picture surface.

Fig. 35 (right)
Dancer with Upraised Arms

PASTEL ON GREY PAPER, 47.6 × 29.8 CM. 1887. FORT WORTH, KIMBELL ART FOUNDATION

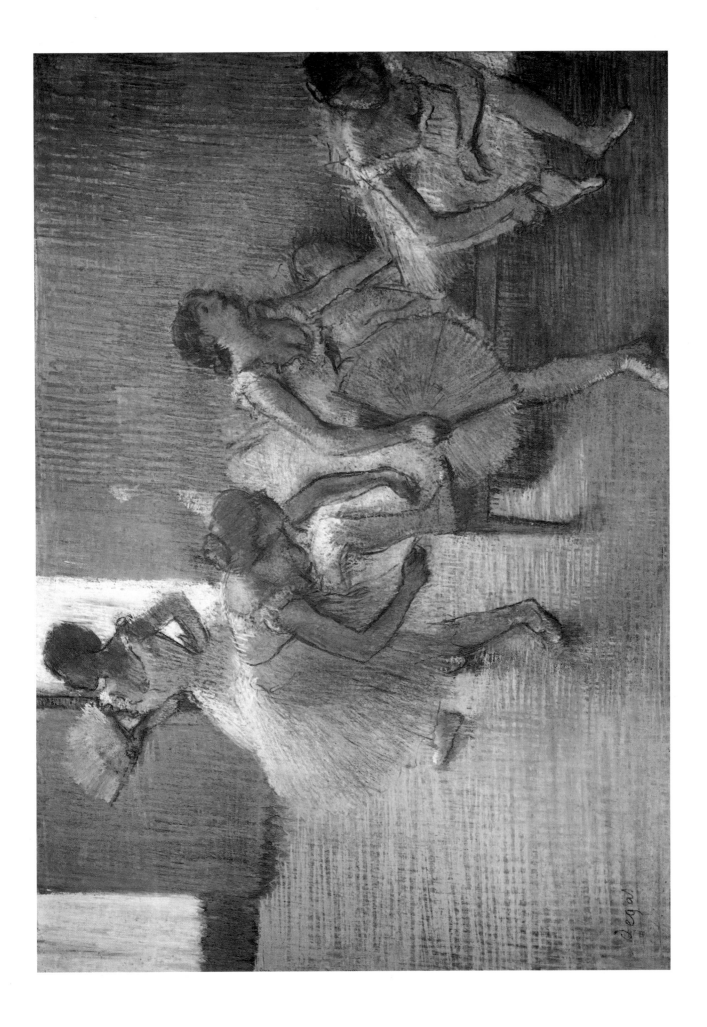

Combing the Hair

CANVAS, 114 × 146 CM. C.1890. LONDON, NATIONAL GALLERY

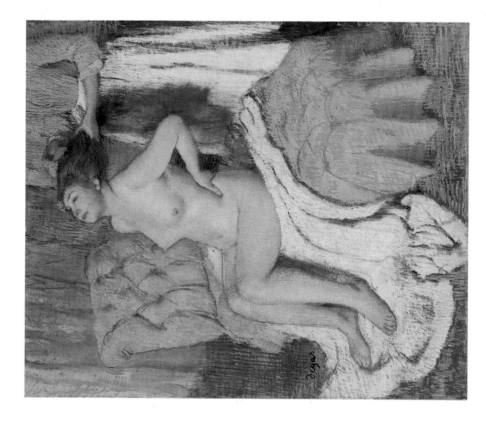

Fig. 36 (right)
A Woman Having her Hair Combed

PASTEL, 73 × 59 CM. C. 1886. NEW YORK, METROPOLITAN MUSEUM OF ART

Degas produced a number of variants on the theme of women and maids at their toilet. This painting is clearly unfinished, but none the less we may appreciate the clarity of focus and uncanny certainty of design. It would undoubtedly have been worked up into a rich glow of colour sweeping over the firmly grasped figures. Degas has united the figures in a powerful pattern of angular movements that move in a forceful diagonal across the surface of the canvas from bottom left to top right. He contrasts the vertical pose of the maid, and her quietly purposeful action (the kind of habitual gesture that Degas appreciated in the laundresses) and the dramatic sweep of the girl's body, which has been forced into taut, jerky movements by the unnaturally strained pose. The vehemence of the picture contrasts with the calmer rendering of a similar theme in an earlier pastel drawing (Fig. 36). Here the maid is less important and is cut off by the picture-frame; the space is more compressed and the emphasis is on the full body and unusually relaxed pose of the nude.

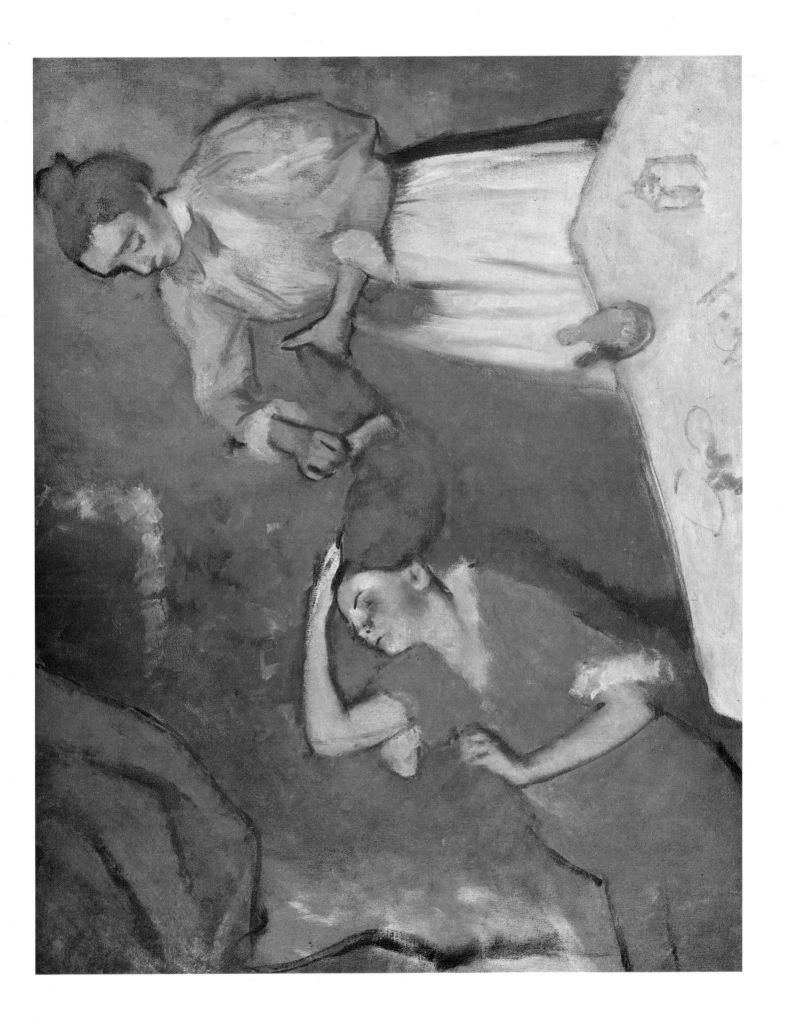

Dancers in Blue

CANVAS, 85 × 75.5 CM. C.1890. PARIS, LOUVRE (JEU DE PAUME)

In his late ballet pictures Degas often showed dancers preparing for the performance, set against decorative stage flats. The *Dancers in Blue* is a variant of a picture in the Metropolitan Museum, New York, which includes the shadowy profile of a man leaning against the stage flat. This picture is less anecdotal, and the emphasis is on the extraordinary beauty of the colour. The space is shallow, and the plane emphasized by the vertical band of the flat; the blue dresses of the dancers create a delicate surface pattern against the varied textures of the background. By this date Degas was almost blind, and he rubbed on the paint with his thumb and fingers; the faces have become patches of almost arbitrary colour. The Cleveland *Frieze of Dancers* (Fig. 37) has a similar decorative beauty, but the surface design is less intricate, and the rhythm gentler. Degas has here juxtaposed four views of one of his favourite figures, the ballet dancer tying her shoe. It is the largest of a series of frieze-like compositions that were begun around 1879. In these late works Degas was more interested in exploring the formal possibilities of a few gestures and movements than in inventing new motives.

Fig. 37
Frieze of Dancers

OIL ON CANVAS, 70 × 200 CM. 1893–8. CLEVELAND MUSEUM OF ART

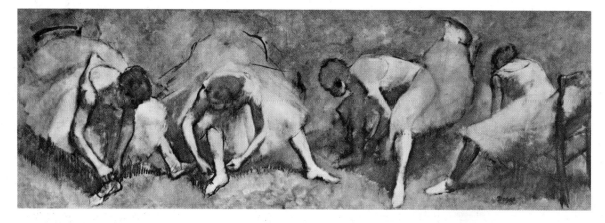

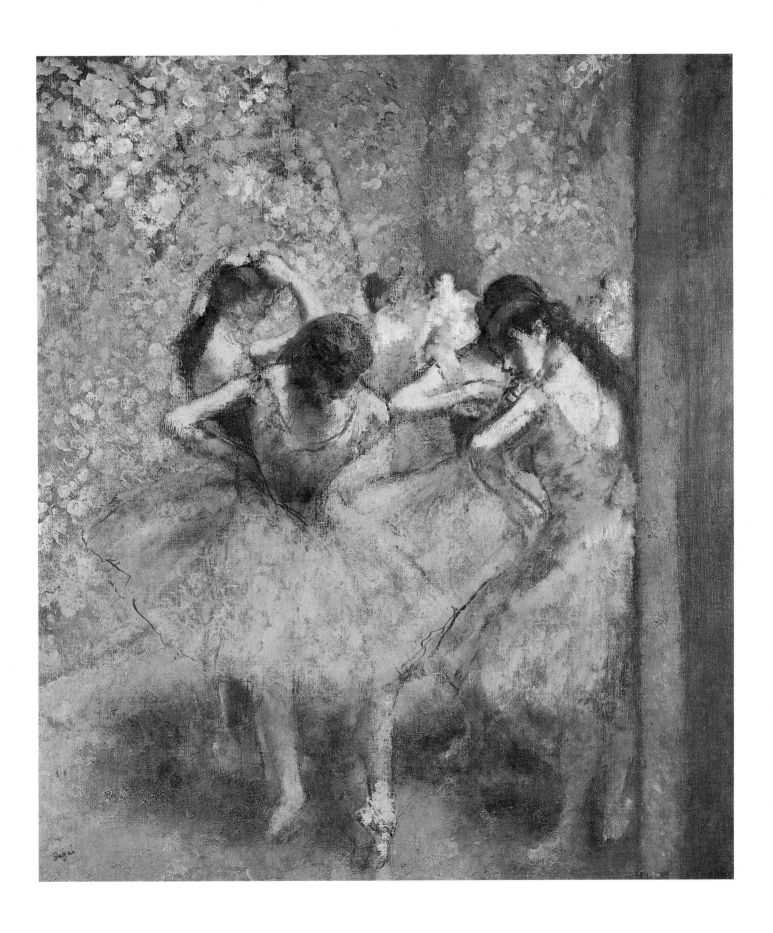

Woman Drying Herself

PASTEL ON PAPER, 64 × 62.75 CM. C.1890–5. EDINBURGH, NATIONAL GALLERY OF SCOTLAND (MAITLAND GIFT)

In Degas's late pastels, as his eye-sight fails, the drawing becomes looser and bolder, the colour more exotic. There is an expressive, almost violent quality in his rendering of the complicated pose of this late nude. Compared with *After the Bath: Woman Drying Herself* (Plate 41) the tensions seem unnatural, exaggerated by the shallowness of the space; the woman's body is caught between two areas of light. She has become part of an almost abstract pattern of both fiery colour, applied with astonishing roughness and vigour, and rich contrasts of texture. The strokes of the pastel – the long verticals that cut across the rounded contours of the bottom, the zigzag pattern on the back, the flat patch of blue that abruptly interrupts the line of the leg – are no longer descriptive, but emphasize the surface, and stress the sense of conflict between surface and depth created by the twisted pose of the woman.

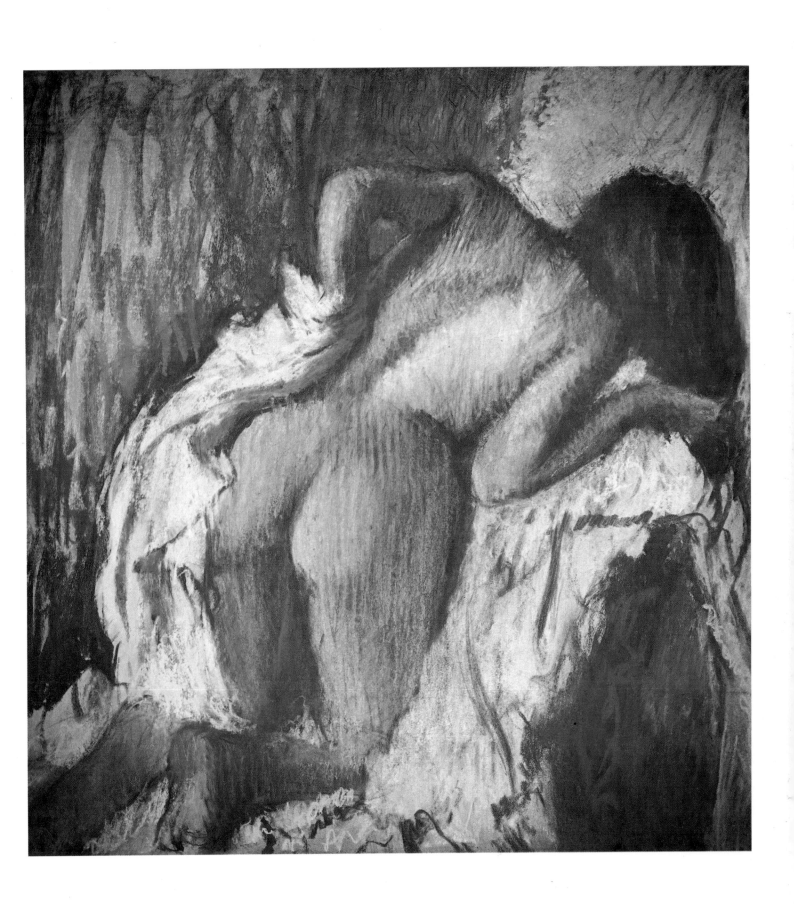

Ballerinas Adjusting Their Dresses

PASTEL, 60 × 63 CM. C.1899. PRIVATE COLLECTION

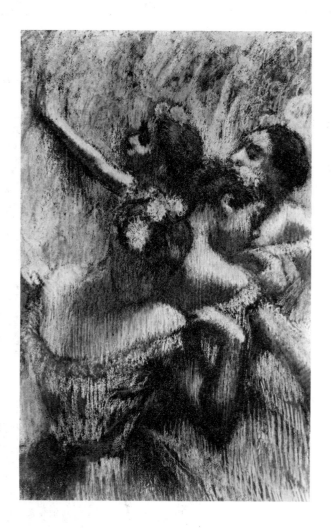

As Degas's eyesight dimmed and his perception of the outside world weakened, his style became more violent and more expressive; his late pastels of ballet dancers attain an almost visionary intensity. Forms are fuller, almost sculptural: thick strokes of pastel create a rich surface that seems to vibrate with fiery, fantastic colour. This pastel is one of a series in which he experimented with the characteristic gestures of a group of dancers waiting in the wings before a performance. The attitude of the girl lifting her arm to adjust her shoulder-strap fascinated Degas, and it appears in several pastels and drawings. Here he juxtaposes three views of the same gesture, and weaves them with the figure raising her arm above her head into a dramatic pattern of light and colour. In other works the pattern is varied – the figures are seen from different viewpoints, or they are more spread out across the surface. In some, the *Four Dancers* for example (Fig. 38), the composition is more compressed, and dominated by bold diagonals.

Fig. 38 (left)
Four Dancers

PASTEL ON PAPER, 64 × 42 CM. C.1902. PRIVATE COLLECTION

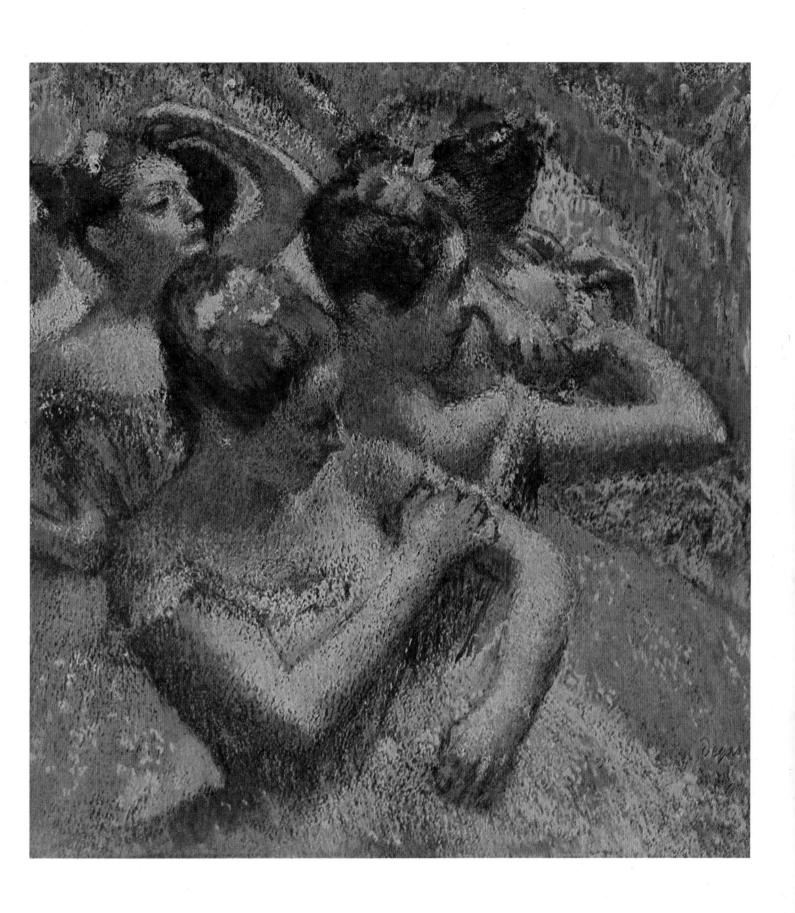